VIBRANT
CHILDREN'S PORTRAITS

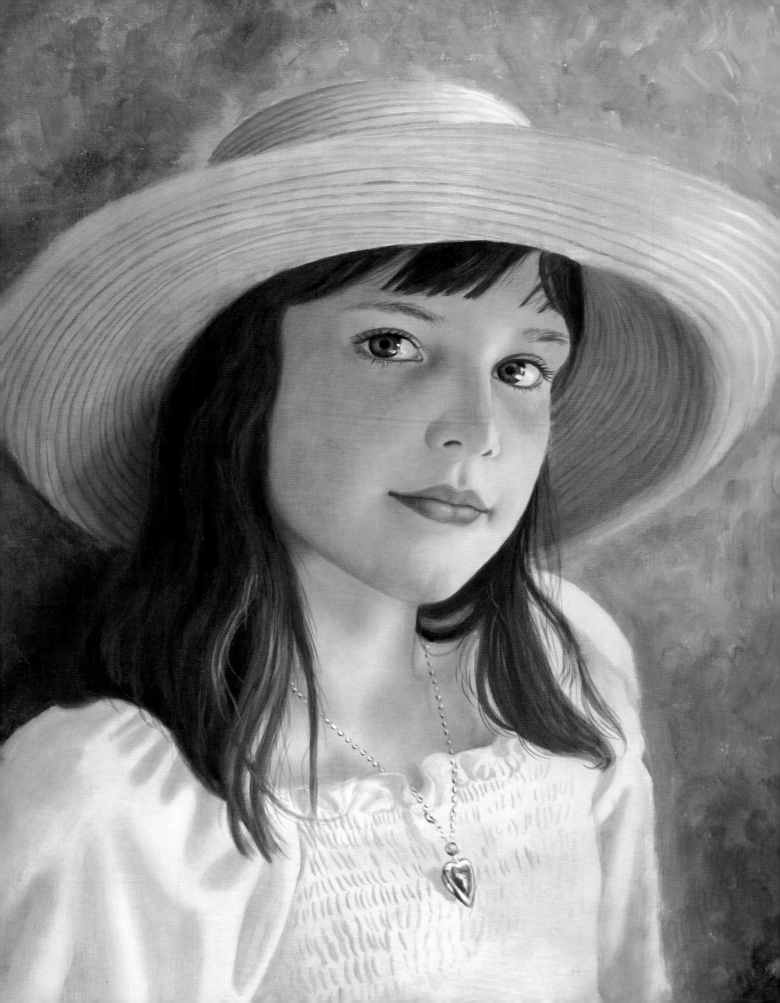

VIBRANT
CHILDREN'S PORTRAITS
PAINTING BEAUTIFUL HAIR AND SKIN TONES WITH OILS

Victoria Lisi

NORTH LIGHT BOOKS
CINCINNATI, OHIO
www.artistsnetwork.com

Vibrant Children's Portraits: Painting Beautiful Hair and Skin Tones With Oils. Copyright © 2010 by Victoria Lisi. Manufactured in China. All rights reserved. No part of this book may be reproduced in any form or by any electronic or mechanical means including informa-

tion storage and retrieval systems without permission in writing from the publisher, except by a reviewer who may quote brief passages in a review. Published by North Light Books, an imprint of F+W Media, Inc., 4700 East Galbraith Road, Cincinnati, Ohio, 45236. (800) 289-0963. First Edition.

Other fine North Light Books are available from your local bookstore, art supply store or online suppliers. Also visit our website at www-.fwmedia.com.

14 13 12 11 10 5 4 3 2 1

DISTRIBUTED IN CANADA BY FRASER DIRECT
100 Armstrong Avenue
Georgetown, ON, Canada L7G 5S4
Tel: (905) 877-4411

DISTRIBUTED IN THE U.K. AND EUROPE BY DAVID & CHARLES
Brunel House, Newton Abbot, Devon, TQ12 4PU, England
Tel: (+44) 1626 323200, Fax: (+44) 1626 323319
Email: postmaster@davidandcharles.co.uk

DISTRIBUTED IN AUSTRALIA BY CAPRICORN LINK
P.O. Box 704, S. Windsor NSW, 2756 Australia
Tel: (02) 4577-3555

Library of Congress Cataloging-in-Publication Data
Lisi, Victoria.
 Vibrant children's portraits : painting beautiful hair and skin tones with oils / by Victoria Lisi. -- 1st ed.
 p. cm.
 Includes index.
 ISBN 978-1-60061-314-2 (hardcover : alk. paper)
 1. Children--Portraits. 2. Portrait painting--Technique. I. Title.
ND1329.3.C45L57 2010
751.45'425--dc22 2009027328

Edited by Mary Burzlaff Bostic and Erika O'Connell
Designed by Doug Mayfield
Production coordinated by Mark Griffin

ABOUT THE AUTHOR

As a child, Victoria Lisi started drawing before she started talking. Her grandfather was a talented watercolorist, and her mother purchased art supplies for her and encouraged her to develop her skills.

Victoria graduated from the Evergreen State College in Olympia, Washington, with a BFA. She works in oil, watercolor and acrylic and has won many awards, both regional and national. Her work is available through the Max'ims of Greeley galleries in Greeley and Estes Park, Colorado.

Portraits, especially of children, have always intrigued her. Eyes are the windows into the soul, and, in children, the windows are the most open. Victoria also enjoys painting animals and landscapes. The quality of light and the way it illuminates a subject are endlessly fascinating.

Victoria has worked extensively in illustration. She has illustrated over a dozen children's books, and provided over a hundred book covers in various genres, including young adult, romance, science fiction, fantasy and new age, as well as assorted magazine covers.

Victoria taught illustration for six years at Western Connecticut State University and currently teaches watercolor, painting and drawing at Aims Community College in Loveland, Colorado.

She sometimes collaborates with her husband and fellow artist, Julius Lisi, on both fine art and illustration. You can visit their website at www.vjlisi.com. Contact Victoria Lisi at vh.lisi@comcast.net.

METRIC CONVERSION CHART

To convert	to	multiply by
Inches	Centimeters	2.54
Centimeters	Inches	0.4
Feet	Centimeters	30.5
Centimeters	Feet	0.03
Yards	Meters	0.9
Meters	Yards	1.1

Margaret (page 2 art) · oil on canvas · 14" × 11" (36cm × 28cm) · collection of Jane Maday

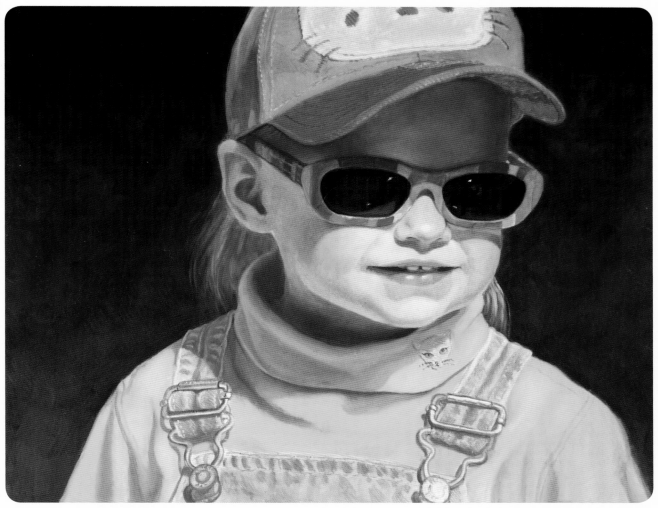

Baby Cool · oil on Masonite · 9" × 12" · (23cm × 30cm)

ACKNOWLEDGMENTS

To my husband and fellow artist, Julius Lisi, who contributed immensely to this book. I could always count on your honesty and excellent eye when I needed to see the paintings more clearly and needed encouragement to keep improving them. Thank you for taking care of everything else when I was preoccupied with this project.

To Jane Maday, a wonderful friend and fantastic artist, who has written many books published by North Light, and who encouraged me to submit this idea. Your constant support throughout the process was invaluable.

To my first husband, Kennedy Poyser, your help and encouragement in my illustration career got me established.

To Kevin Johnson and Rowena Morrill, your expert advice on oil painting helped me in the early years of illustration and ultimately in writing this book.

To acquisitions editor Kathy Kipp for selecting the book and directing its outline.

A very special thanks to my editors, Mary Bostic and Erika O'Connell, who provided excellent direction and advice. You did a wonderful job helping put this book together.

To Ric Deliantoni for technical photographic assistance.

To all my delightful models. It was a pleasure photographing and painting you.

To all my students, who contributed to the book through drawings, reading excerpts and looking at the paintings in progress. Your fresh eyes on the paintings, advice on writing more clearly, and drawing contributions were of great help.

DEDICATION

To my mother, Brigitte Yarborough. Your encouragement, instruction and purchase of art supplies during my formative years placed me on an artistic road that has been a source of joy throughout my life. I can't thank you enough.

TABLE OF CONTENTS

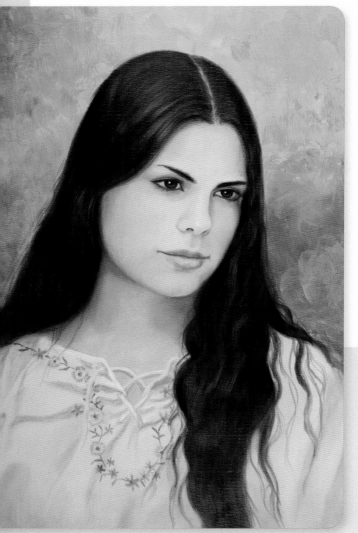

Kaitlyn
oil on canvas
12" × 9" (30cm × 23cm)
collection of Frank and Carol Lisi

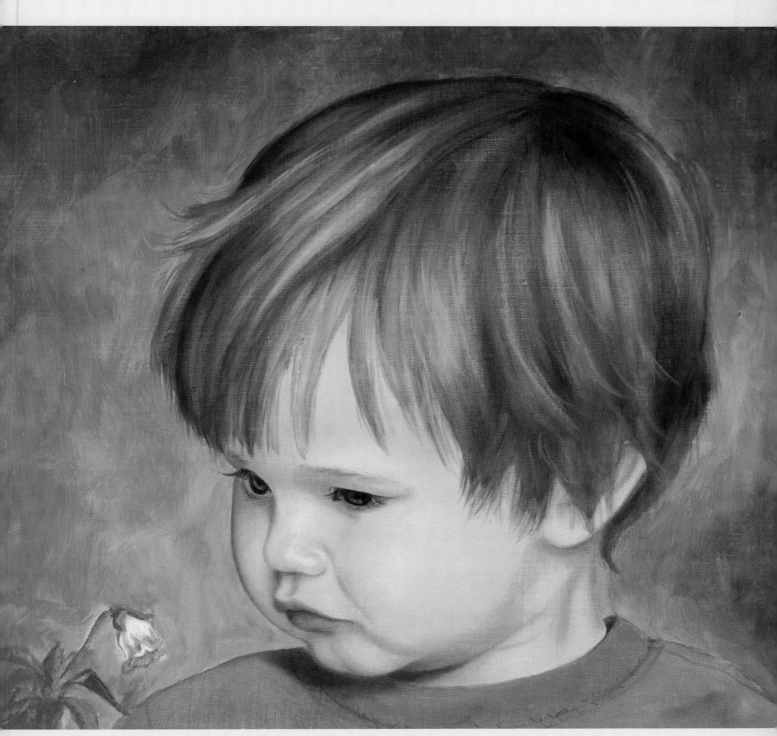

Ben · oil on canvas · 9" × 12" (23cm × 30cm)

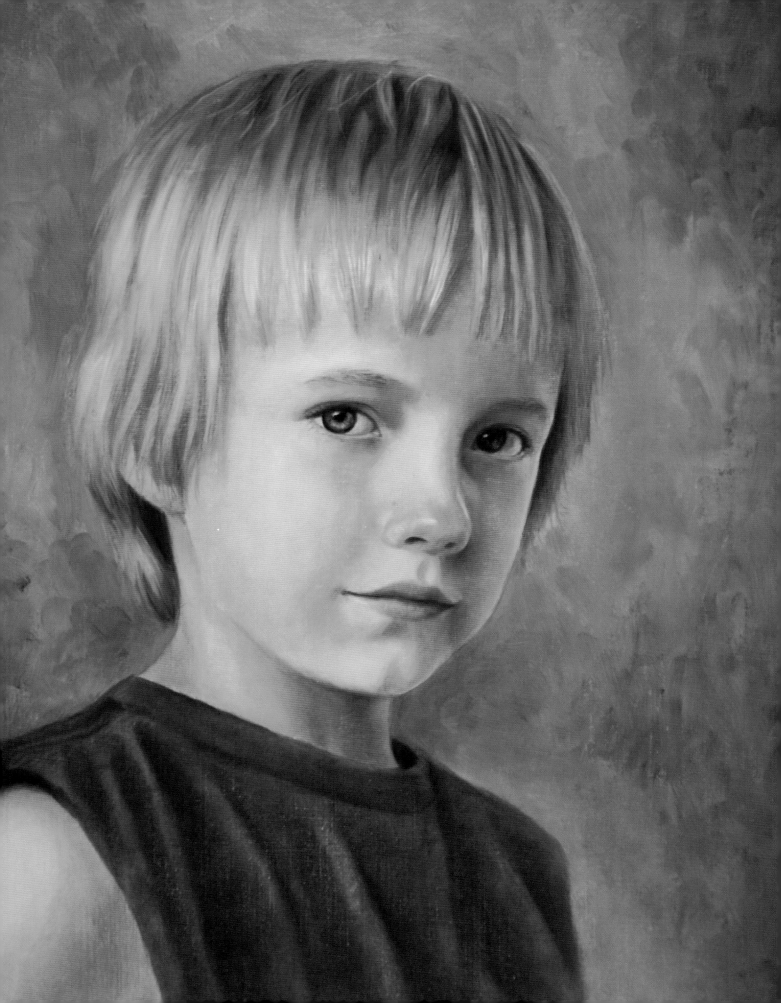

INTRODUCTION

Painting children in oils is both challenging and deeply rewarding. Capturing the beauty of a child in a painting is something you can enjoy while you paint and again years from now. The child will appreciate the portrait when she grows up, and future generations will be able to enjoy it as well. A properly done oil painting will last far longer than a photograph. My mother proudly displays portraits of family ancestors that were painted centuries ago. A portrait of herself as a young girl is among her most prized possessions.

Painting in oils can be a pleasant experience if you understand how to use the medium. In some ways, oils are far easier to work with than watercolors or acrylics. Oils are easy to correct if you make a mistake because the slow drying time gives you the opportunity to adjust the painting. Furthermore, oils are especially suited for painting children because the paints are easy to blend and it's possible to capture the smooth skin tones of the young.

That said, it's important to have realistic expectations. If you are new to painting, you can't expect to master the process immediately. Give yourself some time and practice, and your paintings will improve.

Read the whole book first, from beginning to end. The demos at the end should not be attempted until you have read the earlier parts and completed the exercises. If you want to achieve realism in your paintings, learning to draw accurately is essential. A good drawing is the backbone of a good painting.

Understanding the painting techniques we discuss is the key to using them. Some of the preliminary exercises may seem dull, but if you do them, you will be better equipped to paint, and you will experience far less frustration.

In my years of teaching, I've learned that everyone has hidden depths of artistic talent. Finding how to access this talent is the key. I've found that encouragement plus step-by-step instruction can transform a dedicated novice into a skilled artist. I'll provide the instruction, but you'll have to encourage yourself. Be patient and allow yourself to make mistakes; that's how you will learn.

Portraits have a mysterious quality that goes beyond technique. Good portraits capture a soul quality or essence. I don't believe you can capture an emotional quality unless you have an intimate experience with that quality. To capture the sense of wonder and curiosity of childhood, you need to recapture those senses yourself. Painting in oils is a wonderful way to do exactly that.

Luke
oil on canvas
12" × 9" (30cm × 23cm)

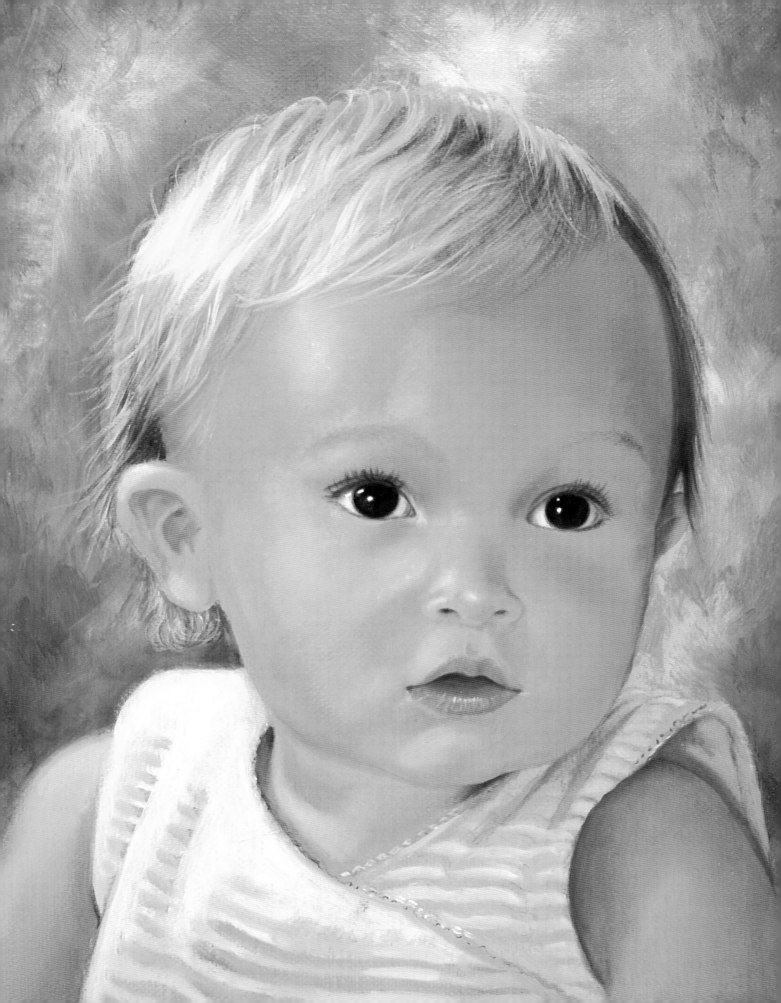

CHAPTER ONE
MATERIALS

Having the right art supplies makes a big difference in your results. As an art teacher, I have often seen the shock that comes to students when they exchange their cheap brushes and dried out paints for quality materials. I have experimented and researched for years to find out which tools are the best for achieving the results I want. I recommend that you do likewise. Experiment to find your own favorite materials. Try out the ones I suggest in this chapter. Go to gallery openings and talk to artists. Peruse art books, websites and magazines, and follow the suggestions of artists whose work you admire. My students develop favorite brushes, paints, mediums and surfaces that are different and unique to each individual.

Brown Eyes
oil on canvas
12" × 9" (30cm × 23cm)

PAINTS

Quality paints make a difference. Cheap paint doesn't provide the necessary coverage for a richly colored painting. The brands I prefer are Winsor & Newton Artists' Oil Colours, Daniel Greene Oil Colors and Daniel Smith Original Oil Colors. There are many quality companies on the market. I prefer to avoid any toxic materials such as cadmium. There are cadmium substitutes called *hues* that work well (you'll find "Hue" at the end of the pigment name). Experiment and find out which brands and colors work best for you.

Pigments

Oil paints are made by grinding pigments and combining them with drying vegetable oils such as linseed oil. The Old Masters had secret recipes that they passed down to their apprentices through various schools. Modern manufacturers have duplicated many of the qualities of these secret recipes. Quality oil paints have a rich, buttery feel and a depth of color and luminosity.

MY PALETTE

The following list includes all the paints used in this book. You don't need such an extensive list to start painting though. Look at the skin tone palettes (pages 53–56) for the colors you're most likely to use.

Winsor & Newton Artists' Oil Colours
Bismuth Yellow, Burnt Sienna, Burnt Umber,* French Ultramarine,* Green Gold,* Indian Yellow Deep,* Mars Black,* Naples Yellow Light, Permanent Alizarin Crimson,* Permanent Magenta,* Rose Madder Genuine, Terra Rosa, Titanium White,* Transparent Maroon,* Transparent Red Ochre, Transparent White, Venetian Red,* Winsor Blue (Green Shade), Winsor Green, Winsor Magenta, Winsor Violet Dioxazine,* Yellow Ochre Pale

Winsor & Newton Winton Oil Colours
Cadmium Orange Hue, Cadmium Red Hue, Cadmium Yellow Hue

Winsor & Newton Griffin Alkyds
Burnt Sienna, Indian Red, Indian Yellow

Daniel Greene Oil Colors
Burnt Umber Cool,* Burnt Umber Warm, Red Rose, Violet Deep*

Daniel Smith Original Oil Colors
Cadmium Red Scarlet Hue,* Cadmium Yellow Medium Hue*

*These are my favorite colors.

ARTIST'S TIP

Even though I use nontoxic paints, I try to avoid getting paint on my skin. There are art guard products you can rub on your hands to protect them. In the past, people washed brushes with soap, using their hands to rub the paint out, but this is unhealthy. Buy a nontoxic product that cleans brushes. I rub brushes in a small porcelain cup with nontoxic cleanser first, then with soap and water. I then rinse out the brush in water in a Bob Ross brush cleaning bucket with a screen that fits inside. Many other suitable cleaning products are available in art and hobby stores. Plain hand soap will work, but rub a brush full of paint into the sink, not into your skin.

PALETTES

To paint with oils, you need a palette that is suitable for oil paints, not one that will absorb the oil out of the paint. You can use a piece of glass with sanded edges or a wooden palette that has been sealed with varnish. Most artists carefully clean their palettes between painting sessions, but not always. I once visited an artist who added more and more paint to an old glass palette. There were flies stuck in it! She felt it added texture in her abstract work. That would never work for me. Because I like to use very fresh paint, paper palettes are my choice. They can be used for several days.

Paper Palettes

If you buy paper palettes, make sure the package notes that they are suitable for oils. These palettes come in pads and are specially coated to prevent the oil in the paint from seeping out. Once you are finished with one, peel off the top sheet and start with a clean sheet. There are many excellent brands available. Most are white but some are gray or beige to assist with color mixing. I place my paper palette inside a Masterson Sta-Wet Palette, which is normally used for acrylics. It has an airtight seal. Masterson's Artist Palette Seal will work as well. Find a paper palette pad that will fit easily inside the plastic palette with the seal.

Once the paint is dried out, I throw the paper palette sheet away. I do not like to use paint that has dust, lint or anything else in it.

Large paper palettes designed for oils that are placed in a plastic sealable container work well. There are excellent products in art and hobby stores that are usually marketed for acrylics. You can also use a large flat Tupperware container. If you place the tightly sealed palette in the refrigerator, the paint will last longer between sessions. Since oil painting requires extensive mixing, this saves time and paint.

BRUSHES

A few good brushes are preferable to a dozen poor ones. Years ago a professional artist recommended a professional brush to me; I was amazed at the difference. Good sable brushes are expensive, but less expensive synthetic brushes have improved dramatically in recent years. They work just as well and last longer than sables.

BRUSH SHAPES

Oil brushes come in different shapes and degrees of stiffness that are useful for different stages and areas of portrait painting. The hair or background might require texture, while skin might need soft blending. Synthetics can mimic the stiff boar bristle or the soft sable as well as the degrees of stiffness in between.

Here are some of the brushes I use:

- **Filberts** are the workhorse for the techniques in this book. The oval shape of the filbert allows for a wide range of strokes, from broad areas to narrow spaces. This versatile brush creates soft edges and works well for portraits. I like the Winsor & Newton Monarch filberts. Look for a quality filbert that has a bit of stiffness (but not too much). Synthetic mongoose fits the bill. Larger, stiffer, synthetic hog-hair filberts are excellent for backgrounds.
- **Short filberts** have a little more control and are good for tight areas. Synthetic mongoose is a good choice.
- **Rounds** are useful for the areas that are too tight even for short filberts. I use long-handled synthetic mongoose rounds. Winsor & Newton Monarch rounds are reliable. Skip this brush if you're on a tight budget.
- **Synthetic watercolor** or **watermedia rounds** are not traditionally used for oil painting. They are designed for watermedia such as watercolor or acrylic. I find them invaluable for the detailed realism represented in this book. They are softer than traditional oil rounds, and the short handle gives you more control. They are useful for very smooth skin tones. Synthetic brushes designed for acrylics last the longest. The brushes should come to a sharp tip. I like Winsor & Newton Cotman brushes and Jack Richeson's Stephen Quiller brushes.

- **Miniatures**, sometimes called **spotters** or **mini brushes**, are commonly used to paint miniatures. They have short hairs that come to a very fine point, but are stiff enough to handle oils. Filberts in very small sizes such as 10/0 will also work. Miniatures offer the control and precision necessary for details such as eyelashes. Test the brush before you use it. Dip the brush in water provided at the art or craft store, then tap or flick the bristles and see if they return to a sharp, precise point.
- **Glazing** or **blending** brushes are soft, oval or round brushes, useful for soft blending. My favorite is the Habico Lasur Oil Glazing Brush, but many other brushes will work. If you can't find this, look for a soft, fluffy mop brush (normally sold for watercolors). Use this brush as if it were a cosmetics brush to blend skin tones.
- **Flats** should be springy, not too soft or stiff. Synthetic mongoose is a good choice, but many other brushes are fine.
- **Combs** work well for straight hair. They are like flats with an uneven edge.
- **Homemade fans** are more irregular than the store-bought variety and are useful for curly or kinky hair. Make a homemade fan from a worn-out round brush. Spread the bristles into a splayed shape and hold them with a clothespin or clamp (see page 74). Then, drop some acrylic medium at the base. Let this dry. Alternately, you can take a small worn fan and snip the ends to be more irregular.

ARTIST'S TIP

Different companies use different names and descriptors for the same brush. Try to think of the function of the brush and what shape would be best for that function to avoid being confused by labels.

Quality Brushes

You simply cannot get good results without quality brushes. Here are some of the brushes I use most frequently.

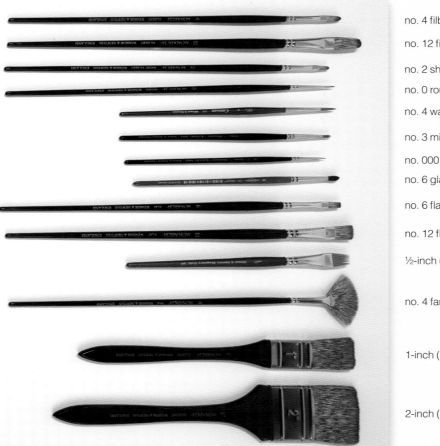

no. 4 filbert

no. 12 filbert

no. 2 short filbert

no. 0 round

no. 4 watercolor round

no. 3 miniature

no. 000 miniature

no. 6 glazing brush

no. 6 flat

no. 12 flat

½-inch (12mm) comb

no. 4 fan

1-inch (25mm) flat

2-inch (51mm) flat

WHERE TO USE EACH BRUSH:

I've indicated my brush choices throughout the step-by-step text in this book's demonstrations, but it's helpful to have a general idea of where to use each brush in portrait painting. Here are some guidelines:

- **Smallest Miniatures and Spotters (nos. 00, 2)** for the finest details, such as eyelashes, eyebrows and thin strands of hair.
- **Larger Miniatures and Spotters (nos. 3, 4)** for fine details, such as eyes, lips and nostrils. These require a fine point with a bit of stiffness.
- **Short Filberts (nos. 2, 4)** for applying skin tones with precise control.

- **Filberts and Rounds (nos. 00–4)** for skin tones, hair and clothes.
- **Larger Filberts (no. 6 and up)** for backgrounds and glazes.
- **Glazing Brushes and Fans** to blend. They should be very soft.
- **Watercolor Rounds** for wavy and straight hair, skin and clothes. The more fluid strokes are good for long strands of hair.
- **Combs** for straight hair.
- **Flats** for straight hair, glazes and backgrounds.
- **Homemade Fans** for curly hair.
- **Larger Flats (1-inch [25mm] and 2-inch [51mm])** for priming and toning canvas and overall glazes.

CANVASES AND PRIMERS

A surface with the proper absorption and texture for oil painting is especially important when painting children. The subtle nuances of color and the smooth softness of skin are hard enough to paint without fighting the surface every step of the way.

The best surface is gessoed stretched linen canvas. It has a pleasing natural texture that complements skin tones. Quality cotton also works well, though it has a slightly more regular surface. Look for a fine grain recommended for portraits.

To prepare the surface, sand the canvas lightly and give it an additional coat of primer. Primers or gessos are available in acrylic and oil formulas. If your canvas is already primed with an oil-based primer, any additional primer must also be oil based. You can paint oil over acrylic, but you can't paint acrylic over oil. I used Winsor Newton Oil Painting Primer for the portraits in this book. Once the primer is dry, sand it lightly.

The best size for children's portraits is 9" × 12" (23cm × 30cm). It's an easy size to work with because the head and shoulders can comfortably fill the canvas at life size or slightly smaller than life. It makes for a more natural portrait if a child's face is not larger than life size. Working very small is more difficult because mistakes stand out more.

The Key to Luminosity

The key to achieving a luminous painting is to start with a very white canvas. Luminosity is an optical effect created by light going through the translucent layers of paint and bouncing off the white canvas. I use both Jack Richeson Extra Fine Grade Oil Triple Primed Linen Canvas with a portrait texture to which I add one coat of primer, and Winsor & Newton Artists Quality Stretched Cotton Canvas, which is already very white and does not require primer. Any good quality canvas with a reasonably fine grain will work.

ARTIST'S TIP

I noticed a significant difference in my results when I switched from Masonite to linen. The texture of linen or cotton grabs and holds the paint, giving good coverage. The slicker surface of Masonite can be frustrating to work on, requiring more layers of paint for a smooth look. However, many artists get great results with Masonite.

MEDIUMS, SOLVENTS AND VARNISHES

Oil paints require mediums, solvents and varnishes to protect the painting or make the paint thicker, thinner and more or less fast-drying.

MEDIUMS

Mediums improve the flexibility of the paint film. Fast-drying mediums really speed up the painting process. If you don't use them, your painting will take a long time to dry. Use medium consistently, either the same approximate amount throughout the painting, or gradually add more or less. If you use inconsistent amounts, the paint will adhere poorly.

Use regular fast-drying mediums in all but the last stage of painting. For the final stage, use a thinner fast-drying medium that allows for delicate glazes and fine details. Winsor & Newton Liquin Fine Detail works well.

SOLVENTS

Solvents are used to clean brushes and thin the paint. Since I am sensitive to smells, I prefer a low-odor solvent with low flammability. This type of solvent is also less toxic. You only need to use a tiny amount. Too much weakens the paint film and causes poor coverage. I prefer Winsor & Newton Sansodor because of its low toxicity.

VARNISHES

Varnish protects the finished painting from dust, dirt and yellowing. Varnishes are available in gloss, matte and satin finishes. The one you choose is a matter of personal preference. I like Krylon Kamar Varnish, but there are a number of good varnish brands. Spray varnish is easier to use than the type you brush on. Be careful and spray outdoors after the painting has thoroughly dried.

ARTIST'S TIP

There are three traditional rules for oils:
1. Fat over lean: Use more oil in each layer as the painting progresses. The paint on top must be more flexible than the paint on the bottom.
2. Slower-drying over faster-drying paint: Violating this rule could cause your painting to crack.
3. Thick over thin: Thicker paint should be applied over thinner films. I sometimes paint a glaze over a slightly thicker coat, but generally all my coats other than the background are very thin.

ARTIST'S TIP

Do not add medium to Burnt Umber because this pigment dries very quickly. Add a little more fast-drying medium to Titanium White since it dries much slower than other colors.

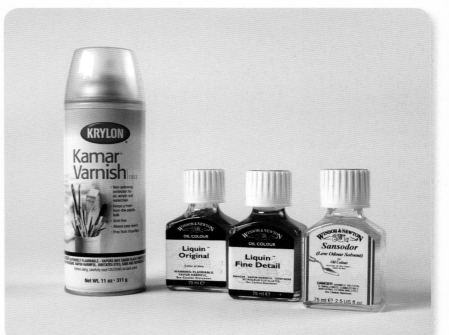

The Best Products for Oils
Look for mediums that speed drying to make the process faster, solvents that are less toxic and varnishes that offer UV protection. Use only products that are labeled as suitable for oils. Products designed solely for acrylics will adhere poorly and may cause your painting to crack.

OTHER SUPPLIES

In addition to the basics, there are a number of other products that aren't necessary but can make painting easier, quicker and more comfortable. Some of these you can make yourself.

• **Color wheel:** My students are often astonished to find that mixing paints is so much easier with a simple plastic color wheel. Get the kind that spins with cutouts.

• **Gray scale:** This scale helps to determine the value of a color. See pages 48–49 for more information on using gray scales. To make a gray scale, paint a strip of paper with nine values ranging from white to progressively darker grays until you reach black. To make the gray scale more useful, punch holes in each value with a hole punch so you can peep at the value you wish to match. Laminate it for durability.

• **Grid art products:** These transparent, reusable sheets with premeasured grids save you the long, tedious mathematical process of gridding when using the grid method of drawing (see page 43).

• **Hem gauge:** This inexpensive mini ruler with a plastic attachment is used for measuring clothing hems. It can be found in the sewing department.

• **Mahlstick:** This is a pole with a ball at one end that you use to steady your hand. Hold the mahlstick in your nondominant hand, end resting against the painting or easel. Then rest your painting hand against the length of the mahlstick to steady your hand. You can use a simple, inexpensive dowel in the same way for small canvases.

• **Mylar:** Denril Multi-Media Vellum Drafting Film and other similar plastic film products make for a really sturdy tracing paper that can withstand erasing and will last throughout the painting process, allowing you to retape it to your painting over and over again to check for errors.

• **Palette knives:** These are useful for mixing colors and painting backgrounds.

• **Paper towels:** Bounty paper towels don't leave lint and are great for spreading or wiping off paint.

• **Plastic eggs:** Use the eggs to help you visualize the form of the head and place the facial features.

• **Red transfer paper:** This works well for transferring drawings to canvas. Other colors will work, but red blends more naturally with skin tones.

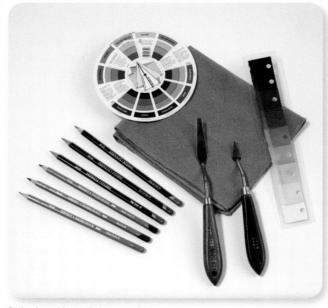

Coloring Materials

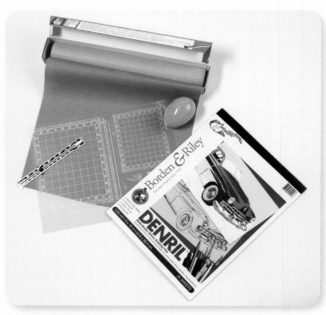

Drawing Materials

- **Regular colored pencils:** Use these at the end of the painting process for fine details or texture.
- **Tack cloths:** These work well for removing dust between stages in the painting process. Wait until one stage of the painting is dry and gently daub it with the tack cloth. You can use wax-coated fabric, but I prefer soft microfiber tack cloths because they are gentler on the paint surface.

- **Watersoluble colored pencils:** These are useful for filling in any gaps you missed while transferring a drawing. Red works well because it blends naturally into the flesh tones. Watersoluble colors dissolve into the paint.

My Work Space

Painting with oils is a slow process. It can be frustrating to try painting at the kitchen table between meals. Set up a work station in a corner to give you the space and the time to work.

I have cats, so I store my oil supplies in a small rolltop desk. When I need a break, I roll down the top and leave my palette out. I tape blotter paper on the desk surface to preserve it.

You don't need anything this elaborate. Before I had cats, I painted for years with an old bedside drawer as my taboret.

I place my easel so it gets north light. I also have a combination table lamp that uses both a long-lasting, color-correcting 22-watt tube and a 100-watt incandescent bulb. The two different bulbs can be turned on separately or together to check the painting under different lighting conditions.

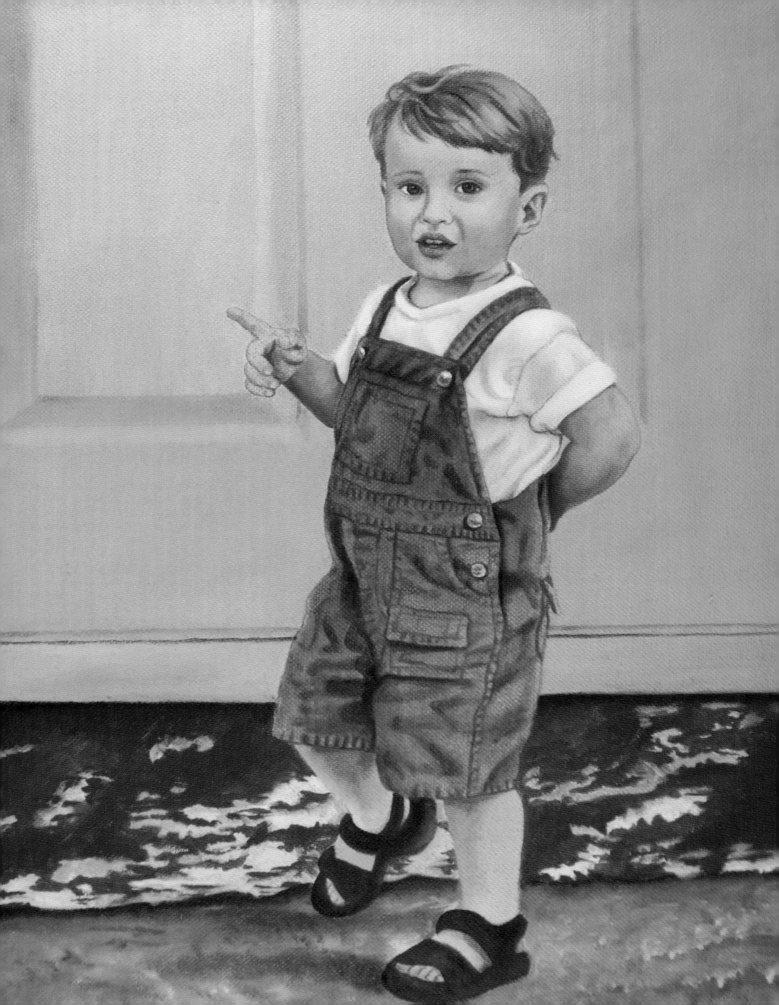

CHAPTER TWO
PROPORTIONS

The most common problem encountered in painting children is proportions that are off and more adultlike. To create paintings of children that look like real children, it's important to understand the differences between children and adult proportions. Children are not simply small adults. They have larger heads and shorter limbs that gradually change as they grow. Their facial features are also shaped and spaced differently. Making your subject look age-appropriate is key to good portraiture.

Read this chapter carefully and apply the principles to your preliminary drawings. Even when tracing, errors in proportion can develop if you aren't familiar with the basic proportional rules. When laboring over the individual facial features, it's easy to lose sight of the overall face. Check the proportions throughout the drawing and painting process. I've found that the beginning of each step is a good time to check.

Green Jeans
oil on canvas
16" × 12" (41cm × 30cm)
collection of Melissa Roth Cherniske
from a photo by Melissa Roth Cherniske

BODY-TO-HEAD RATIO

Adult head size varies very little, though height can vary greatly from one adult to another. The average adult stands 7½ heads tall (this measuring unit is the height of an average adult head), though this can vary. Children's height obviously varies as well, depending on age and the individual child. There are some general rules, but the best way to determine the head-to-body ratio is simply to measure it. There is no substitute for observation.

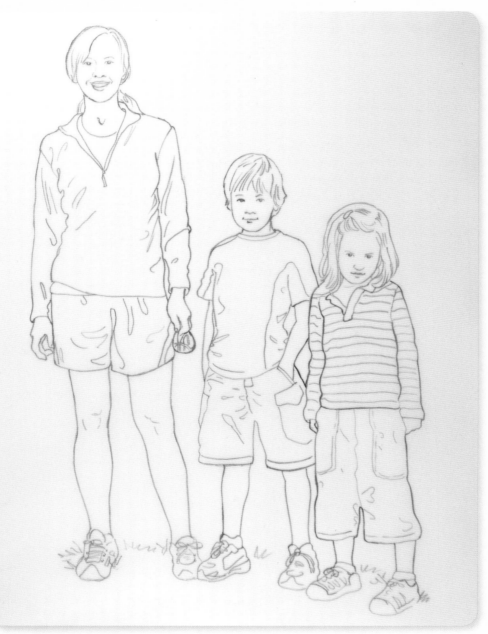

Adult and Child Head Sizes

The boy in this drawing is seven years old and the girl is five. Compare the size of the adult's head to the children's heads. The adult is taller, but the head size is similar. Heads grow from babyhood to childhood to adulthood, but not nearly as dramatically as bodies.

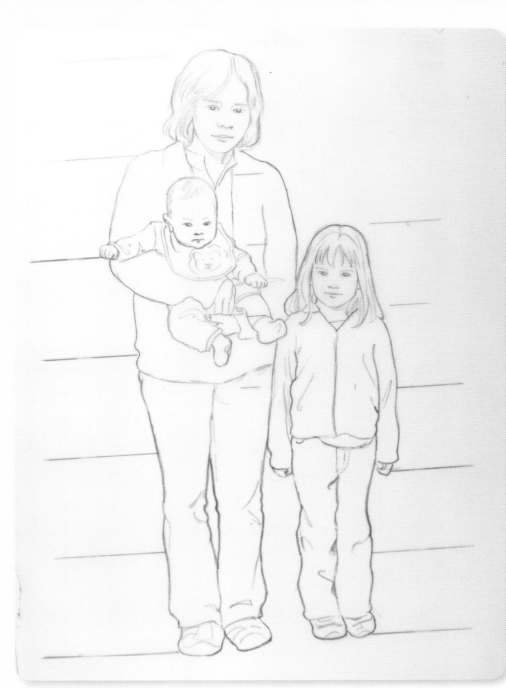

Varying Heights

The horizontal lines represent head lengths. Shorter adults have a shorter body length; tall adults are tall because of their greater body length (adult head size varies very little). Babies are born with fairly large heads in proportion to their bodies. The little girl is six years old. Notice how the body grows more than the head as people age.

ARTIST'S TIP

The angle of the camera affects the perception of proportions and height. Shooting reference photos from below the waist will make adults and children look taller; shooting from above the waist will make the head look larger and the body shorter.

EYES

The eyes are the focal point of a child's portrait. They are windows into the mysterious realm of the soul. Children have the most direct and frank gaze. They haven't learned the more guarded and socially nuanced adult expressions. The innocent look in the eyes of a child is crucial to the success of the portrait. Use various techniques to enhance the eyes, such as making the pupils the darkest dark. You can further emphasize this by making the glint in the eye the lightest light.

FRONT VIEW

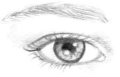

1 Draw two almond-shaped ovals. Babies, toddlers and young children have eyes that are wider apart than in adults. The younger the child, the rounder the eyes.

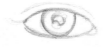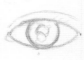

2 Sketch the irises, pupils and eyebrows. Eyes are symmetrical in a front view, so make sure the irises and pupils match. If necessary, use a circle template. The iris is comparatively larger, with less white showing than in adult eyes. The eyebrows arch over the outer corners of the eyes.

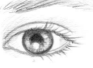

3 Shade the irises and pupils, bearing in mind the shadow cast by the eyelids. The top of the iris will be darker where the eyeball meets the lid. Keep the glint white. Eyelashes are long and delicate. The eyebrows are also very delicate. If you make either too heavy, the child will look harsh and too grown up. The eyes are not as deep set as adult eyes, so make the shading more subtle.

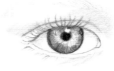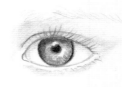

Toddler Eyes, Front View
Notice the difference in the eyes of a younger child. The irises are larger, the lashes and eyebrows are more delicate and the eyes are wider set.

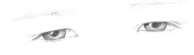

Ethnic Differences

The eyes of children with Asian heritage are generally more angular, with more of the eye covered by the lid. The eyes are not slanted. They are less deep set, and the eyelashes are usually straight.

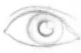

Eyes in Profile

Viewed in profile, the eyes take on a very different shape than they do from the front. Their shape appears more triangular with a rounded front. The iris and pupil have a more oval shape in this view.

THREE-QUARTER VIEW

1 In a three-quarter view, the eyes are different sizes. The closer eye is longer in length, while the farther eye is shorter (because you don't see all of it). The height of the eyes should be the same. The farther eye is usually the more difficult to draw accurately because of its angle. Do not make both eyes the same almond shape. The farther eye is rounded where it curves away from the viewer. The length between the eyes varies, depending on the angle of the head.

2 Drawing the iris and pupil so that they look correct is tricky. They might not be the same size, depending on the angle. The eyebrow arch will vary as well. Observe your reference very carefully.

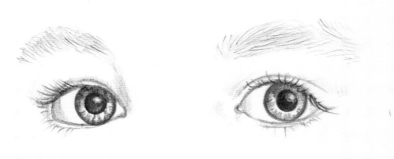

3 Notice how the individual eyelashes and eyebrow hairs curve differently. Draw each hair separately, noting where the individual hair curves rather than just stroking them all in the same direction.

NOSES

Observe the nose of your subject very carefully as the nose changes fairly dramatically from infancy to adulthood. It also varies from one ethnic group to another. The shading on a nose is usually fairly subtle unless the lighting is unusually dramatic.

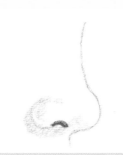

Eight-Year-Old's Nose, Front View
A child's nose is more rounded and less angular than an adult's. It protrudes less from the head and is more upturned.

Toddler's Nose, Front View
A baby's nose is buttonlike and more upturned. As a child ages, the nose turns down and the bridge becomes more prominent.

Nose in Profile
The profile of a child's nose changes from very rounded to more angular with age. The button shape is still noticeable in this profile of a five-year-old.

THREE-QUARTER VIEW

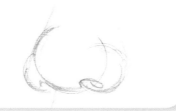

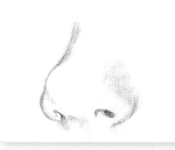

1 Noses in three-quarter view can be especially difficult. Start by observing the underlying shapes. In this case there are three circles. Draw these lightly with a circle template. Notice how the circles overlap. The circle farthest away is mostly obscured.

2 Add the nostrils. The nostril farther away is hardly visible. Draw the nose shape following the circle guidelines. This will help keep the shapes rounded.

3 Erase the circle guidelines and add the shading. The tip of the nose is slightly more angular. Keep the farther nostril small.

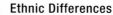

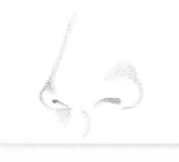

Ethnic Differences
The noses of children with African heritage are generally wider and flatter in appearance. They are usually less angular and more softly rounded. They also tend to protrude less.

LIPS

Lips are challenging but fun to draw and paint. As a child grows, the lips change from the bow shape of a baby's to the longer shape of an adult's. The lips' shape also changes dramatically from a serious expression to a smile to a laugh. The lips of babies and toddlers are often wet. There are ethnic differences to consider as well. When painting the lips, maintain the line between the lips and the interior of the mouth. Also, make both the interior of the mouth and the line between the lips a dark reddish color. This makes the face look alive.

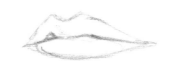

Front View

In a front view, the lips are symmetrical. The upper lip has an indent in the middle of the lip. Sometimes there is a smaller indent on the bottom of the lower lip. Children's lips are smaller, rounder and more bow shaped than the lips of an adult, but there is enormous individual variation.

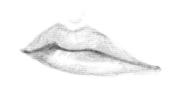

Lips in Profile

In very young children, the upper lip protrudes over the lower lip, giving them a slight overbite. This changes as the jaw grows and the characteristic is gradually lost.

THREE-QUARTER VIEW

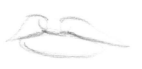

1 The nearer side of the lip is longer than the farther side. This is tricky, and careful observation is crucial. Draw two tear shapes for the upper lip and an oval for the lower lip.

2 Define the lip shapes using the triangle and oval shapes as guides. Bring the corners of the mouth out and make sure the upper and lower corners meet.

3 Shade the lips. The upper lip of a young child or baby may be more pronounced and larger than the lower lip because the jaw is less developed.

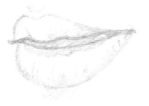

Ethnic Differences

Children with African heritage tend to have fuller lips, though the way the mouth and jaw develop is the same. The younger the child, the more bow shaped the mouth.

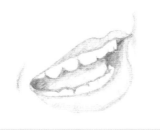

Adding Teeth

Don't overwork teeth with too much detail. This tends to make the teeth look dirty. Draw and paint the outer edge of the teeth carefully, but don't overdo the spaces between the teeth.

EARS

There is enormous variety in ears. Each person's ears are unique. Younger children's ears are smaller and more round. Ears get longer and larger as a child grows.

Ears can be intimidating to draw and paint, but they don't have to be. Just observe and analyze the shapes that you see. Break them down into smaller shapes and go from there. Sometimes it helps to feel your own ears as you work. When painting ears, use red in the shadow areas. This will make the portrait look more alive.

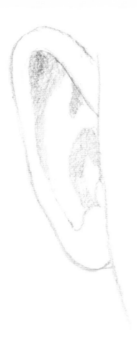

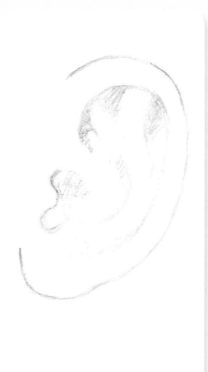

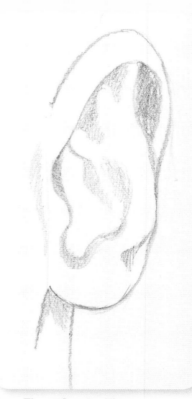

Ears, Front View
The ears from the front don't show as much as they do from the side. Some ears stick out a lot more than others.

Ears in Profile
The oval shape and swirling circular inner shapes of the ear are more obvious in this side view. It takes patience to carefully record the shapes you see.

Ears, Three-Quarter View
This angle is the hardest to draw or paint because of the foreshortening. Some cartilage may stick out at this angle that isn't obvious from the other angles. Draw what you see as faithfully as you can.

ARTIST'S TIP

Sometimes it helps to turn both your drawing and your reference upside down and work on it. This allows you to see the shapes that are really in front of you rather than concepts that are in your mind.

DEVELOPING A LIKENESS AND A SWEET EXPRESSION

It's a good idea to observe a child and have a number of photos to study. Certain features will stand out that might not be obvious from a single photo. Eye, skin and hair colors can be off in a photo. Take notes if you see the child in person. Photo colors vary due to time of day, indoor or outdoor lighting, etc. The most accurate light is outdoor north light.

Try creating a caricature of your subject. A caricature bears a likeness to a person even though it is not technically accurate. This is because caricatures emphasize features that are specific to the subject. Obviously you don't want to paint a caricature, but a quickly drawn caricature can help you if the child has distinctive features you want to be aware of while painting. For many artists, there is an unconscious tendency toward self-portraiture in painting. Check and recheck your painting as you proceed to make sure it looks like the child you are painting.

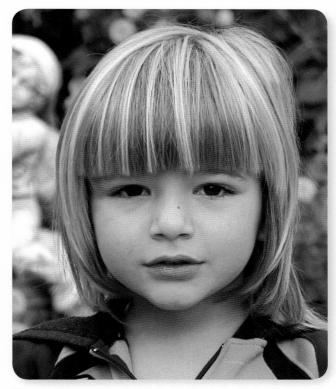

Keys to Cute
Children have pronounced neonatal features that make them look cute. Babies, children and young mammals share these characteristics. If you compare a child to a kitten, you'll see that they share several characteristics:

- high forehead
- round, wide-set eyes
- small button nose
- small chin

Illustrators employ these features in everything from children's books to greeting cards. Toy manufacturers use them in dolls and stuffed animals. Most people find these features cute and appealing. If you fail to capture these features in a child, he will look off. Don't overdo it either. Take careful note of what neonatal features the child you are painting has and record them faithfully. There is a further intangible quality of wonder in children; this comes through better if you cultivate this sense in yourself.

FACE DEMONSTRATION
FRONT VIEW

A front view makes for an attractive and appealing portrait. It's as if you are gazing directly at the child. The challenge is to make the face symmetrical. This is harder than it looks. The guidelines and measuring will help you overcome this difficulty. Use the hem gauge to make sure the eyes are the same size.

Reference Photo

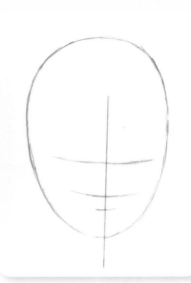

1 DRAW THE HEAD AND GUIDELINES

Study the underlying egg shape of the head in the reference photo. Draw this symmetrical oval shape with a series of short pencil strokes.

The eye line in an adult face is usually halfway between the top of the head and the chin. The younger the child, the lower the eye line. Measure your reference, then draw the horizontal eye line.

Draw a vertical line cutting the egg in half. Place the bottom nose line halfway between the eye line and chin. Place the mouth line one-third down the space between the nose line and chin.

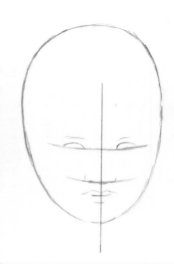

2 PLACE THE FACIAL FEATURES

Place the eyes along the eye line. Indicate where the eyebrows will go. Use the hem gauge to measure the distance between the eyes and the eyebrows, and between the eyebrows and the sides of the face. Place the nose and mouth following the guidelines. Keep the nose and mouth rounded. Measure for accuracy.

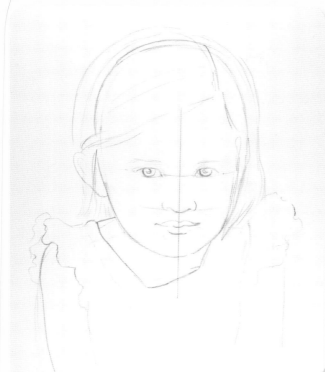

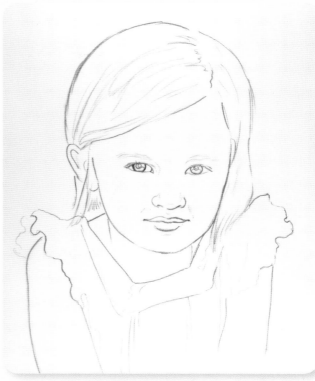

3 DRAW THE FACIAL FEATURES
Fill in the features (see pages 24–27). The iris of a child's eye is larger compared to the rest of the eye, and less white shows. Develop the almond eye shapes. Measure the nose. The sides of the nose line up with the inner corner, of the eyes. The outer corners of the lips line up with the pupils. The upper bow peaks of the mouth line up with the nostrils.

Add the ears (see page 28). The bottoms of the ears are usually in line with the bottom of the nose, and the top of the ears with the eye line. But the placement varies if the face is tilted down as in this picture. Using the hem gauge, place the hair, shoulders and sleeves.

4 REFINE THE DRAWING
You can either continue to refine and develop the drawing and then erase all the guidelines, or you can tape a sturdy sheet of tracing paper or Mylar over the initial drawing. I recommend the latter because you won't have to do a lot of erasing, and you can place the transparent drawing over the painting to check for errors later.

Refine the features. Develop the hair and indicate the shapes of the shadows. Children have thinner necks, and their eyebrows are more delicate. The forehead is higher; the chin is less pronounced. The hair is finer and thinner. Measure to ensure accuracy. Create a visual map that is almost topographical, showing with lines where shadows change value and colors change temperature.

ARTIST'S TIP

Using Mylar or tracing paper saves erasing time and makes it easier to transfer the drawing to canvas for painting. It also allows you to check your painting later for accuracy.

FACE DEMONSTRATION
PROFILE

Drawing profiles of children is fun and educational. You can observe from a different angle how the face and head develop. The profile of an infant is very different from a teenager. Babies are born with relatively large brains. The lower part of the face grows to fit the large skull. The eyes are one of the more challenging aspects of the profile view. They have a very different shape than in a front view.

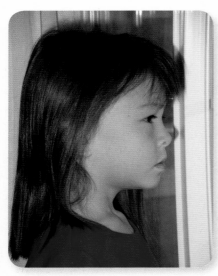

Reference Photo

1 DRAW THE HEAD AND GUIDELINES
Make a tilted egg shape. The younger the child, the more rounded the egg shape. The front of the oval should be flat where the face will be. Place the eye line lower than the halfway mark. The bottom of the nose is halfway down to the chin. The lip line is one-third of the way down from there.

2 PLACE THE FACIAL FEATURES
The forehead protrudes more in children than in adults. The nose is upturned. Place the ear even though it will be covered with hair. The bottom of the ear should line up more or less with the nose line. Children's upper lips protrude, while their chins recede.

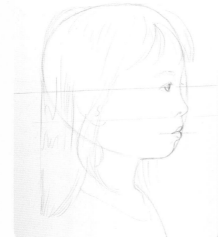

3 ADD THE HAIR
Children's foreheads are higher, so start the bangs at the right spot. Draw the neck. Children's chins are less developed, so the chin will be small.

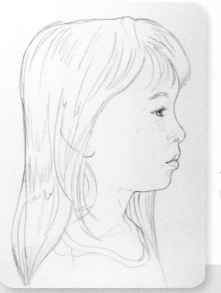

4 REFINE THE FEATURES
Emphasize the curved shapes. Make sure the eyes face forward.

FACE DEMONSTRATION
THREE-QUARTER VIEW

Three-quarter views are the most challenging angle, but they make for great portraits. They look very natural and appealing. Placing the bisecting lines will help you get the features in the right place.

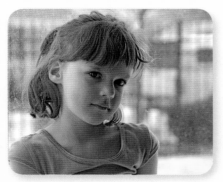

Reference Photo

1 DRAW THE HEAD AND GUIDELINES
Draw a slightly angled egg shape. Make the bisecting lines arc around the shape. If necessary, draw the lines on a plastic egg to get the angles right. The nose and mouth placement varies depending on the angle. Observe and measure.

2 PLACE THE FACIAL FEATURES
Place the eyes, nose, ears and lips carefully along the bisecting lines. Use the plastic egg to see how the features fall at this angle. The bottom of the ear and the nose line up along the curved bisecting line. Be especially careful placing the eyes. Measure to ensure accuracy.

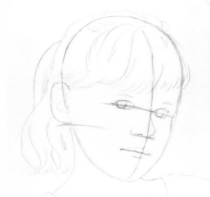

3 DRAW THE FACIAL FEATURES
The eyes are different sizes because one is closer to the viewer than the other and at a more oblique angle. The bridge of the nose obscures the farther eye slightly. The nostrils are also different sizes because they are at different angles. Again, each side of the mouth is different because one side is facing the viewer and the other facing away.

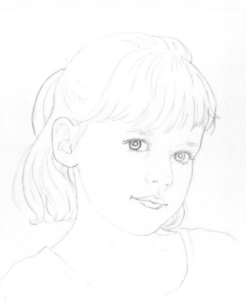

4 REFINE THE DRAWING
Erase the guidelines or place a sheet of tracing paper or Mylar over the drawing and continue drawing. Refine the features and add the hair. Add the pupils, making sure they look in the same direction. Place eyelashes very carefully. They curve at different angles along the eye.

HANDS

Drawing and painting hands can be challenging. There are only general rules since hands can be posed in such a variety of positions.

BABY'S HAND

Baby hands are very plump with short fingers and dimples.

1 Get the overall form down first. Start with some light gestural lines to show the sweep of the fingers and the lineup of the knuckles.

ARTIST'S TIP

When painting hands and feet, use a reddish color between the fingers and toes. It makes them look alive.

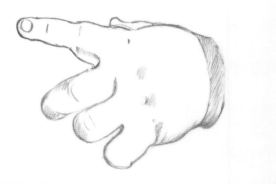

2 Using the lines as guides, draw in the fingers and hand, paying attention to the contours; keep them rounded and plump.

CHILD'S HAND

As a child grows, the hands become more angular with thinner fingers and thumbs.

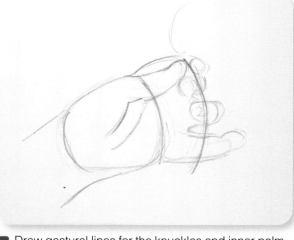

1 Draw gestural lines for the knuckles and inner palm. Draw in the fingers and thumb, making sure the overall form is correct.

2 Finish the hand, paying attention to the subtle contours. Children's fingers are rounded and curved.

FEET

Feet can be even more challenging than hands. The Old Masters really mastered this aspect of the human anatomy. If you have the opportunity to observe paintings of feet up close in a museum, you will learn a great deal.

BABY'S FOOT

Babies' toes are usually curled and rounded because they haven't started standing yet.

1 Start with the basic oval shape and sketch in the toes following the oval contour.

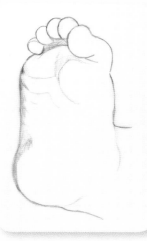

2 Erase the guidelines and refine the contour lines. Bring out the heel, footpads and ankle.

CHILD'S FOOT

As they age, children develop squarish feet that are more similar to adult feet, though they are still more rounded.

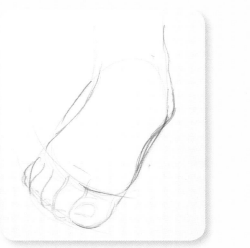

1 Draw a rounded rectangle. Make a line for the angle of the toes, then fill in the toes. Observe how the big toe and smaller toes differ in size. The smaller toes turn under.

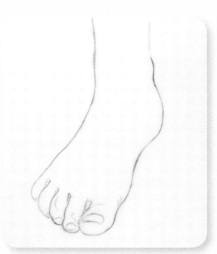

2 Slim the foot with contour lines and refine the toes. Record the shape of the heel and anklebone. The larger toes hide part of the toes beside them from this angle. The child's foot is shorter and rounder than an adult's but not as round as a baby's.

FIXING COMMON PROBLEMS

My students graciously did these drawings for me to illustrate the most common problems encountered when drawing children. The first two sets were from more advanced students who drew the faces incorrectly on purpose, then correctly. The next three were from beginning students who did the incorrect drawings before they received any instructions.

EYES TOO HIGH

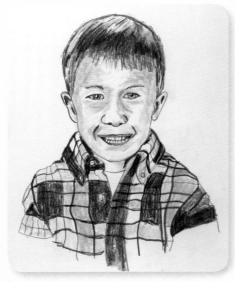

Incorrect
A child's eyes are lower on the face. This drawing with the eyes too high gives the boy an older, more manlike look.

Right
Here the eyes are placed appropriately for a child. The boy looks younger.

Drawings by Robert Vangermeersch

HEAD TOO SMALL

Incorrect
Making the head too small in proportion to the body is another common error.

Right
See how much more childlike the little girl is with the correct head size for a four-year-old.

Drawings by Preston Stone

HEAD SHAPE OFF

Incorrect

When the egg shape of the head is off, the features also appear to be off.

Right

With the head shape more accurately observed, the features fall into place.

Drawings by Dee Dee Sabin

FOREHEAD NOT ROUNDED

Incorrect

Children have very rounded, high foreheads. Also, this hat doesn't look like it fits her head.

Right

The little girl looks more childlike with a higher, more rounded forehead and a bigger hat that fits her.

Drawings by Zachary Inman

LINES TOO HARSH

Incorrect

The lines that indicate cheeks are too harsh and artificially age the little girl.

Right

Here the rounded cheeks are softer and more accurately portrayed.

Drawings by Emily Smiley

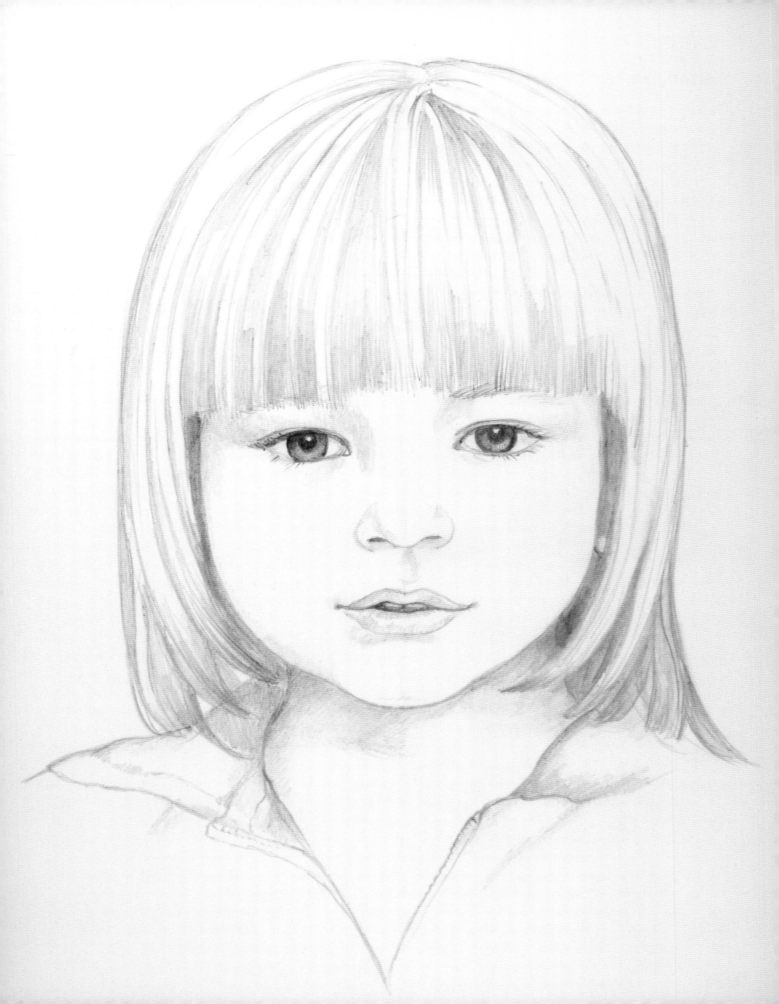

CHAPTER THREE
DRAWING

The backbone of a good painting is good drawing, especially when you want a realistic portrait. As an art teacher, I've watched painting students striving for realism get frustrated because they lack a background in drawing. Traditionally, art students first had to master the art of drawing before they could even attempt painting, but this tradition has faded somewhat with modern teaching methods and abstract art.

When a painting isn't going well and looks off, it's almost always a drawing problem. I encourage you to work out your drawing first before you tackle the painting part. This breaks the process down into easier, more manageable steps. Once you have a good drawing on your canvas, you can then concentrate on values and color. Not realizing that the eyes are the wrong size or misaligned until the painting is almost done makes for an extensive and frustrating repainting process. It's like trying to build a house on a crooked foundation.

Get your drawing right first. Take a break and don't look at the drawing for a few days, then come back to it. This will help you to see the drawing with a fresh eye.

The Italian Boy
graphite on bristol paper
14" × 11" (36cm × 28cm)

SKETCHING FROM LIFE

Sketching from life trains your eye. Even if you use a photograph for painting, your work will have more character if you sketch regularly. You'll understand proportions better and avoid errors due to photographic distortions.

If you have an opportunity to sketch the child, you can record details, impressions and characteristics that a camera would miss. There is a big difference between a photo and a living, breathing child! What sort of personality does she have? Shy? Bold? Impish? Artistic? These qualities will be more obvious as you sketch and interact and will add to your work.

Children of certain age groups, such as babies who haven't learned to crawl yet, lend themselves better to sketching from life. You can do quick gestural sketches when children are active and more finished drawings when they are reading, sleeping or watching TV. Also, attend a life drawing class. Even though you will draw adults, the practice will enhance your work.

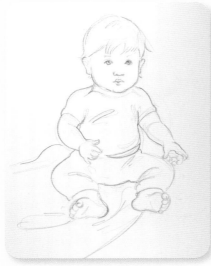
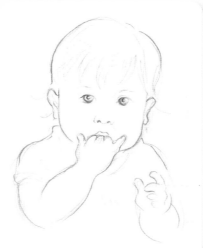
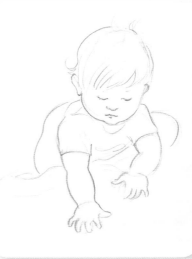

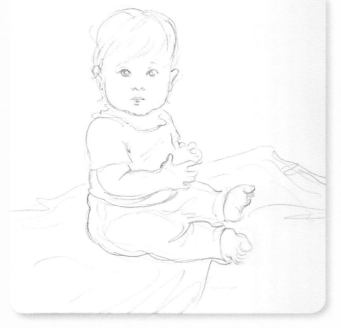

Capturing Personality

One of my students brought his baby to class one day, and I took the opportunity to demonstrate drawing from life to my students. The baby hadn't learned to crawl yet and was quite content to sit on a blanket gazing about, talking baby talk. I tried to capture his easy-going, happy personality in these quick sketches. A photograph could not have conveyed his disposition as well as these sketches based on life observation.

CREATING GOOD PHOTO REFERENCES

In an ideal world, a child would sit still while you paint. Photographs are the next best thing. Take lots of photos. Unless you're an expert photographer and have a particularly cooperative child posing for you, aim for a minimum of fifty shots. Professional photographers with professional models will take up to four hundred shots to get the one that appears in a magazine.

Lighting is key to good reference photos. Natural lighting is lovely. Mornings and evenings are best for low light, which is more flattering and interesting. An overcast day or photographing your subject in the shade also works well and gives natural skin tones.

Aim for form and contrast in your photography. Avoid flash photography as it tends to be flat, which makes it harder to give your painting dimension.

The quality of the photo often has a direct bearing on the quality of the painting. Trying to work from a grainy or tiny photograph is an exercise in frustration. Enlarge the photo to 8" × 10" (20cm × 25cm). Some artists make three versions of a photograph: one with light values, one with medium values and one with dark values. If you have image-editing software, you can manipulate the photos yourself. If not, then a good photo developer can do it. See page 49 for more information about creating black-and-white and sepia prints, which can help you see values more easily.

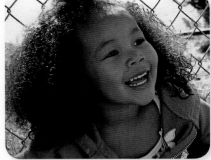

The Best of the Bunch
I followed this little girl around and took over fifty photos. These are the better ones. Notice the way the light falls on her face and hair. The low light gives her hair a halo effect. This is called back lighting. What a delightful smile!

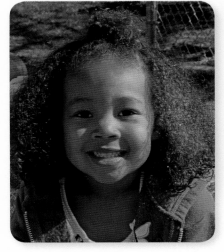

ARTIST'S TIP

Keep a file of photos and reproductions of paintings that inspire you. You might want to use similar lighting or compositions in your own work.

THREE WAYS TO WORK FROM A PHOTO

There are three ways you can work from a photo: by eye, with the grid system and by tracing. Experiment with each one. Whichever way you work, draw for painting rather than for a finished drawing. A drawing that leads to a painting should be a visual map of shapes and shadows. It should have a paint-by-number look; strive to draw the outline of the shapes, values and colors. After you've finished your painting, you can always go back and finish the drawing with shading for a more finished work of art.

BY EYE

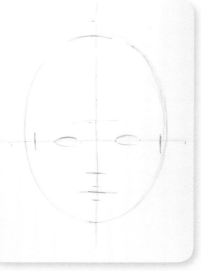

Reference Photo
Drawings that are done by eye can have a liveliness and originality to them that more mechanical means of drawing can't duplicate. Some people are naturally gifted in this area.

1 To draw a likeness, carefully measure and use proportional rules appropriate to the age of the child. Check and recheck your measurements. Remember, the eye line on a child is lower. Measure the reference with a hem gauge or ruler.

2 Make sure the features wrap around the form of the head and are in proper alignment. Placing a plastic egg in the same position as the child's head and with the same light source is useful for placing the features accurately.

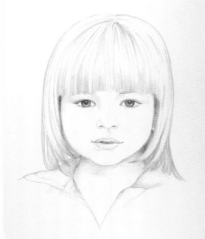

3 Use a high-quality paper such as bristol or vellum that will withstand erasing. Or, to avoid a lot of erasing, try sketching the basic proportions on one sheet and lay sturdy tracing paper over it to finish the drawing.

USING A GRID

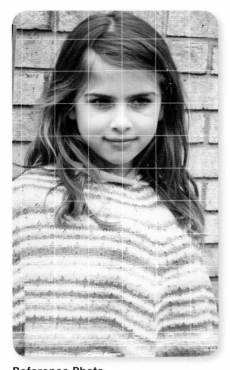

Reference Photo
Drawing with the grid system is a way to ensure accuracy.

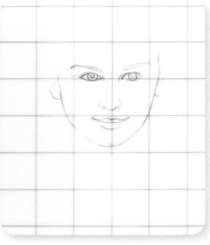

1 Draw a grid on your tracing paper and over your photo. Measure to make absolutely sure that the proportions and ratios are correct. If they are off even slightly, the drawing will be off. You can also purchase grid art products, which are accurate and easy to use.

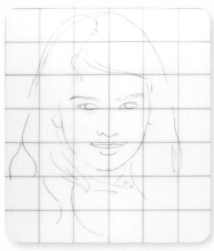

2 Transfer the drawing, square by square.

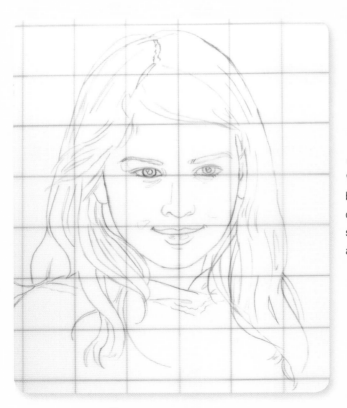

3 The grid method is a slow process. Sometimes it helps to work with both your reference and drawing upside down for a while. This helps you to see shapes and the patterns of value more accurately.

TRACING

When I first began meeting professional artists and illustrators, I was shocked when I found out how many of them traced. Even those who drew beautifully often traced. Their income depends on their painting output, so they do it to save time.

Tracing isn't new. Norman Rockwell traced. Some Old Masters such as Johannes Vermeer and Leonardo da Vinci used the camera obscura. This optical device is the predecessor to the modern camera. It's a box with a pinhole through which light passes. It then projects the scene onto a wall, where it can be traced.

Now there are much more modern means of tracing available. The most obvious is to simply trace a photograph. The advantages are that it saves time and it's accurate. The disadvantage is it can cause your work to look mechanical.

If you love to draw, then do it! If the drawing part bores you and you want to get to painting, try tracing. Even if you do decide to trace for paintings, try to draw as often as possible. It will help you develop your skills.

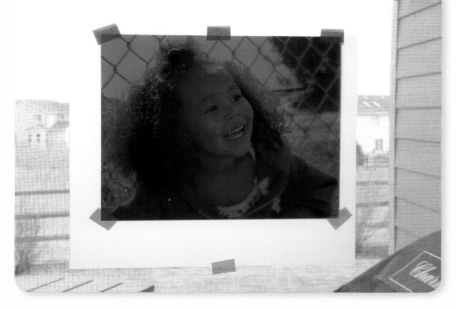

Tracing Possibilities

Tracing can be done any number of ways. The easiest is to tape the photograph to a window and tape the tracing paper over it. Be sure both are secure. Then use a copy machine to enlarge the tracing (or enlarge the photo before you trace). A lightbox serves the same function as a window but is available twenty-four hours a day. Some artists use projectors and slides with great success.

ARTIST'S TIP

Try working on sturdy tracing paper or Mylar so that you can place the tracing over the painting at a later stage to correct any errors that might have developed. It's a good idea to do this at the start of each painting session. If a painting looks wrong, it is almost always a drawing error. There is a tendency as you concentrate on painting to let the features drift out of alignment.

TIPS ON GOOD COMPOSITION

Compositions with overly complicated formulas requiring awkward poses don't usually work well, especially for portraits of children. Children are best left to the natural poses and positions they assume in real life.

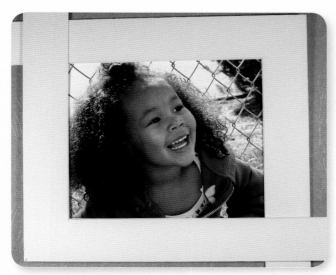

Cropping With L Shapes

Play with L shapes to create a pleasing composition. L shapes are mats that have been cut so you can move them around on a photo. Experiment. Sometimes it's more interesting to move the focal point slightly off center.

ARTIST'S TIP

Don't try to impose different lighting on an existing photo. Instead, take a new photo with the lighting that inspires you. Working from different photos with different light sources creates confusion for the artist and the viewer.

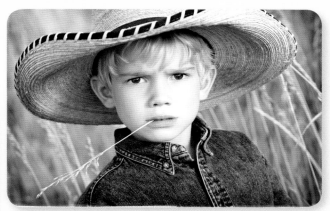

Focal Points

In portraiture, the focal point is usually the eyes. The composition, color choices and values should lead the viewer to this point. Place your strongest darks and lights in the eyes and use lines such as shoulder angles and collars to lead to the face. Hats are great with children and can help them playact like this tough guy seen here.

Photo by photographybydesiree.com

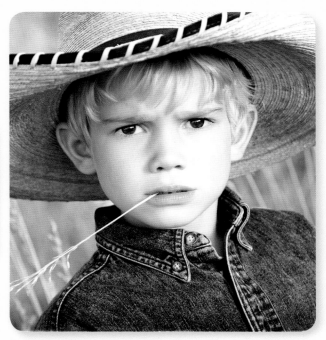

Cropping With the Computer

Many computers have programs such as Adobe® Photoshop® that have crop formats that work beautifully and allow you to play with your image until you get the ideal format.

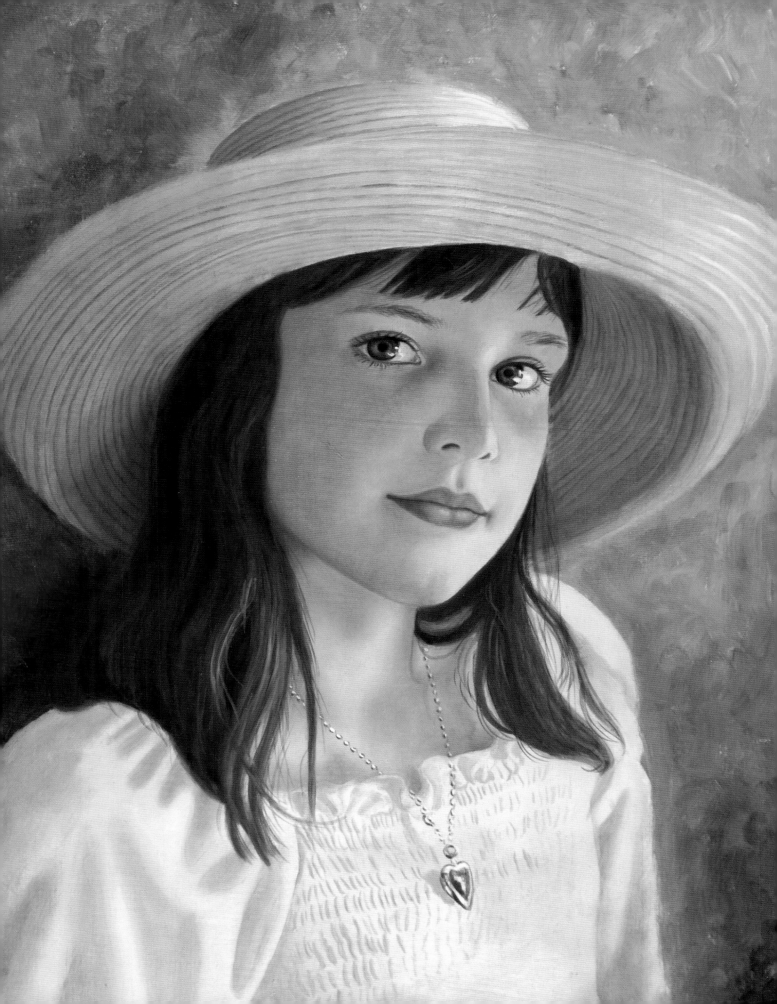

CHAPTER FOUR
SKIN

The range of skin tones is vast. Buying a tube of paint marked "flesh" is completely inadequate. Look at the enormous array of skin tones available at a makeup counter. Some companies even offer customized blends.

Racial ancestry plays a significant role in skin tone. Some children are multiracial with both strong and subtle influences on skin tone. Careful observation is crucial. What color is the skin undertone? Pink, blue, olive, yellow, purple? All sorts of beautiful subtleties exist in skin colors of all races. The skin also changes hue on different parts of the face. Thinner skin, such as at the temples, tends toward more cool tones. The tip of the nose, cheeks and forehead tend toward warmer, rosier hues. This holds true for all races.

Lighting also affects skin tones. Skin color changes dramatically depending on the amount of light falling on it. A strong light lightens the areas of skin where it falls, while low light can darken the skin tones. Even a very light-skinned child will look dark if the light is insufficient. The color of the light also has an influence. The skin tones of a child on a cloudy day or standing in the shade will look cooler. Furthermore, different light sources give different results. Cool northern light gives a cooler bluish hue. Low evening or morning sunlight is pink or orange and affects skin tones accordingly.

If you make a skin chart of all the potential skin palettes, you'll be in a much better position to select appropriate colors.

Margaret
oil on canvas
14" × 11" (36cm × 28cm)
collection of Jane Maday

DETERMINING VALUES

The next step after drawing is establishing the correct values. Value is the degree of lightness or darkness. It is more important to get correct values than correct color. A black-and-white photo is an arrangement of values from black through white with all the grays in between. A person in a black-and-white photo is still recognizable. Imagine looking at the same photos with no values—only colors. The subject probably wouldn't be recognizable. There are a number of tips and techniques for getting correct values.

Using Gray Scales to Mix
A gray scale has eight to ten values, ranging from pure white to black. Lay the gray scale on your reference and painting (only when the painting is dry!) to compare the values. Keep it near your palette when you mix your colors.

Using Gray Scales to Test Mixtures
Laminate your gray scale to try this handy trick. Place a mixture of paint directly on the gray scale to see if it matches the reference. Wipe off the paint with a paper towel once you've established the correct value.

ARTIST'S TIP

Here are a couple of tricks that will help you see values:
1. Squint at your reference or painting. This allows you to see value more distinctly. Make this a habit. Don't try to paint while squinting though.
2. Hold a sheet of acetate or undeveloped film close to your eyes like a pair of spectacles, then view your painting and reference through the colored film. This will remove much of the color, and you will see the values better.

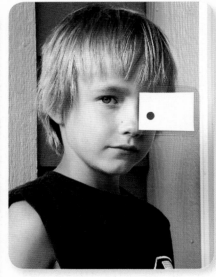

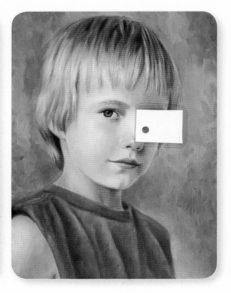

Isolating Values
Punch a hole in two pieces of card stock. Lay one piece on your reference and one on the corresponding area of the dry painting. This will isolate the area so you can better judge value. This technique also works well for selecting colors (see page 59).

PLACING VALUES

Weak values create a weak painting. Strong values draw attention. With children, the values should be subtle and change gradually or they will look too harsh.

Mix a sufficient number of values. I use at least five, but no more than nine. When establishing values, it's better to use more opaque colors. Mix white into all of the lighter mixes. Titanium White is very opaque.

Concentrate on the values early in the painting. Put the darkest color down as soon as you can. It will be a key to determining values in the rest of the painting.

As a general principle, apply dark colors thinly and light colors with more paint. The idea is to let the light of the canvas shine through the darks. The light colors will reflect light automatically.

Place the center of interest in the light area of the painting. Use contrast (such as a black pupil with a light glint) to draw the viewer's attention to the center of interest (usually the eye angled closest to the viewer in a three-quarter view or the eyes in a front view). Avoid extreme value contrast at the edge of your painting, as it leads the viewer's eye off the page.

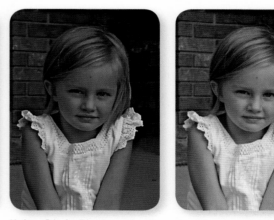

Clarifying Value and Color
To separate value from hue (color), it can help to make a black-and-white and a color print of your reference photo. Use the black-and-white print for the underpainting stage and the color print for the color stage.

Using Sepia Photos
Sepia closely emulates Burnt Umber, which is often used for the underpainting in oils, so it can be helpful for determining the values in underpaintings. Use photo editing software to manipulate and improve your photos to make them more suitable for painting.

ARTIST'S TIP

Black is a controversial color. Some artists never use black from a tube. Instead, they mix dark colors with their complements (colors opposite each other on the color wheel). This creates a black that is more vibrant than pure flat black, which can suck the life out of a painting. Try using tiny amounts of Mars Black at the center of interest. Mix the rest of your darks with complements, such as French Ultramarine and Burnt Sienna, or Permanent Alizarin Crimson and Winsor Green.

BLENDING

Many artists don't advocate blending, preferring a looser, more painterly style. This approach can look great on portraits of adults, but painting the smooth skin of a child calls for blending.

Blending is easier with a properly primed canvas and the right brushes, paints and medium. Opaque colors blend better than transparent ones. Don't try to blend colors that have begun to dry out. You'll have a streaky mess. Use a good brush with the right level of stiffness to apply paint, such as a synthetic mongoose filbert.

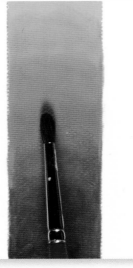

Soft, Rounded Brush
Once you've applied the paint to the canvas with a filbert, use a soft, rounded brush, such as a mop or glazing brush, for blending. Always use a clean, dry brush.

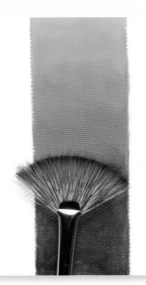

Fan Brush
Fans are also good for blending.

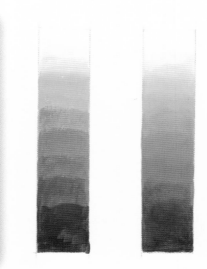

Practice Blending
Select three colors from one of the skin tone palettes (see pages 53–56), and lay them out on your palette. Thoroughly mix a drop of medium into each color. Mix nine values from light to dark and place them side by side on your canvas (see left bar above). Use a glazing or fan brush to blend, creating a blended bar that goes smoothly from light to dark. It usually takes two coats to get it really smooth (see right bar above).

If you have trouble, make sure you take enough time to mix the paint. You may not have mixed enough values, or the paint might be dried out. It should be buttery, not too liquid or too stiff.

Toddler Skin
I applied the paint with a no. 2 short filbert. I didn't blend the paint after applying it.

Toddler Skin, Blended
Here is the same image after I blended the paint with a no. 6 glazing brush. The skin is much smoother.

GLAZES

Glazing produces rich colors with luminosity and depth. It is a wonderful technique for finishing the painting process. Glazing is done with only transparent colors. These allow light to pass through the paint film and bounce off the paint underneath, almost like a sheet of stained glass or acetate overlaid on the painting. Because oils dry slowly, it's usually possible to apply only one or two glaze layers per painting.

It's best to use opaque colors in the early stage and transparent colors in the later glazing stage. If you try to use only glazing colors at the beginning, you won't get coverage and your work will look streaky. A glaze will make an area darker in value.

Practice glazing transparent colors over dried opaque ones to get a sense of what this technique can add to your work. Mix a drop of fine detail medium in your glaze color. Paint the transparent coat thinly, spreading it with your glazing brush or fan.

See the list of transparent colors below. Of course there are more transparent colors than these. Many manufacturers' tubes are labeled opaque, transparent or translucent. If not, there's a simple way to test colors. Draw a black line with a marker on canvas. Paint color swatches over it. Opaque colors will cover the line better, while transparent colors will let the line show. The colors that are in between are translucent.

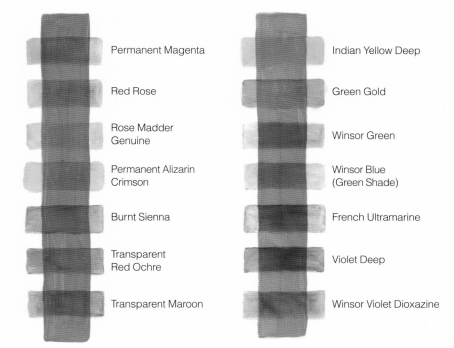

Permanent Magenta

Red Rose

Rose Madder Genuine

Permanent Alizarin Crimson

Burnt Sienna

Transparent Red Ochre

Transparent Maroon

Indian Yellow Deep

Green Gold

Winsor Green

Winsor Blue (Green Shade)

French Ultramarine

Violet Deep

Winsor Violet Dioxazine

TRANSPARENT COLORS FROM MY PALETTE

Burnt Sienna
French Ultramarine
Green Gold
Indian Yellow Deep
Permanent Alizarin Crimson
Permanent Magenta
Red Rose
Rose Madder Genuine
Transparent Maroon
Transparent Red Ochre
Violet Deep
Winsor Blue (Green Shade)
Winsor Green
Winsor Violet Dioxazine

Glazing Chart

Make your own chart once you know which of your colors are transparent. Paint an opaque flesh strip using any of the skin tone palettes, and let it dry. You can use fast-drying medium to save time. Then, mix transparent colors with a thin, fast-drying medium and apply them over the flesh strip. This will give you an idea of how skin colors might respond to various glazes.

SCUMBLING

Scumbling is the opposite of glazing. To scumble, take a lighter opaque color (usually white or an opaque color mixed with white) and paint it over a darker area. It changes the temperature, producing a cooler, more bluish color. Scumbling is a little tricky because it can cause an unexpected color change, such as turning blond hair greenish. It can produce beautiful pearly skin tones when done properly. You can alternate glazes and scumbles at the end of your painting for a really beautiful finish.

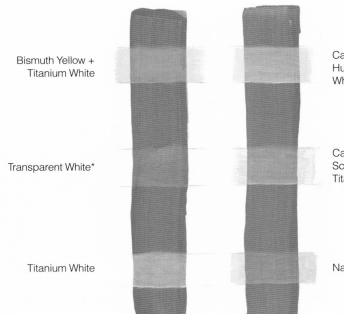

Bismuth Yellow + Titanium White

Cadmium Yellow Hue + Titanium White

Transparent White*

Cadmium Red Scarlet Hue + Titanium White

Titanium White

Naples Yellow Light

Prescumbled Skin
Here is a painting before scumbling. See how the skin is a bit too orange.

Opaque Colors Useful for Scumbling Skin
Using scumbling and glazing properly can take a relatively lackluster painting and add dimension and mystery. Scumbling and glazing are best used at the end of the painting process.

To experiment, paint opaque swatches of different skin colors and let them dry. Add fluid medium to a lighter opaque color and scumble it over the skin tones. Spread the lighter opaque scumble coat very thinly, creating a thin veil of color. Observe the change in temperature.

Transparent White is more transparent than Titanium White. It is useful if you want a very delicate scumble. Even though it's called "transparent," it will create a scumble rather than a glaze.

Scumbled Skin
Here is the same painting after scumbling. Notice how the skin is cooler and bluer after scumbling. This is an optical effect created by applying light over dark.

LIGHT SKIN TONES

Light skin tones range from pearl through peach, olive, beige and brown. Some have freckles. Children of Northern European descent often have more pink tones while those of Southern European descent may have more olive.

White, red and yellow create a generic light skin tone. Different reds and different yellows produce different results.

So will different proportions of paint ratios. On some children the areas of thinner skin will require some blues. Mixing a blue with an orangey red and white can also yield light tones.

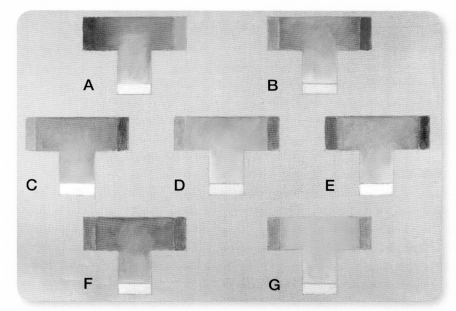

Opaque Chart of Triads

Here are some combinations with each mixture including two pigments and Titanium White. The ratio of the other two colors changes the temperature. The amount of white changes the value. White always cools and grays the colors it's mixed with. Titanium White makes transparent colors opaque.

A. Permanent Magenta + Cadmium Yellow Hue + Titanium White
B. Yellow Ochre Pale + Permanent Alizarin Crimson + Titanium White
C. Yellow Ochre Pale + Transparent Maroon + Titanium White
D. Indian Yellow Deep + Terra Rosa + Titanium White
E. Cadmium Red Scarlet Hue + French Ultramarine + Titanium White
F. Cadmium Red Scarlet Hue + Winsor Blue (Green Shade) + Titanium White
G. Green Gold + Rose Madder Genuine + Titanium White

Glaze and Scumble Chart

Here is a chart with strips of opaque light skin tones that have been further modified with glazes (Transparent Red Ochre and Rose Madder Genuine) and a scumble (Titanium White). Notice how each affects the colors.

Cadmium Yellow Hue + Permanent Magenta + Titanium White

Yellow Ochre Pale + Permanent Alizarin Crimson + Titanium White

Cadmium Red Scarlet Hue + Winsor Blue (Green Shade) + Titanium White

Transparent Red Ochre Rose Madder Genuine Titanium White

DARK SKIN TONES

There is a wide range of dark skin tones. Colors can range from delicate mochas to golden honeys to rich mahoganies. Some areas, such as lips, may have a deep rose, a soft pink or a subtle violet cast. Palms and soles are often lighter than other areas.

Mixing complements (colors that are opposite each other on the color wheel) makes interesting dark skin shades. Varying the ratio will help give nuance and life. This is a better strategy than simply using paint from a brown tube, which can look flat.

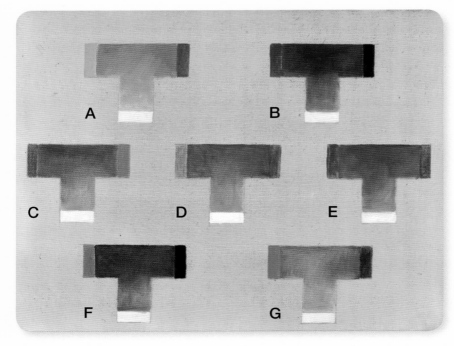

Opaque Chart of Triads

Here are some combinations you can use. Dark skin benefits from colors with strong tinting strength and less white in some areas.

A. Cadmium Yellow Hue + Winsor Magenta + Titanium White
B. Venetian Red + Violet Deep + Titanium White
C. Winsor Blue (Green Shade) + Cadmium Red Scarlet Hue + Titanium White
D. Green Gold + Winsor Magenta + Titanium White
E. Venetian Red + French Ultramarine + Titanium White
F. Cadmium Red Scarlet Hue + Violet Deep + Titanium White
G. Cadmium Red Scarlet Hue + Winsor Green + Titanium White

Glaze Chart

After you have painted dark skin tones opaquely, enhance the colors with transparent glazes. Transparent Maroon is one of my favorite glaze colors. It's particularly effective on dark skin. Purples and magentas can be effective in selected areas such as the shadows and lips.

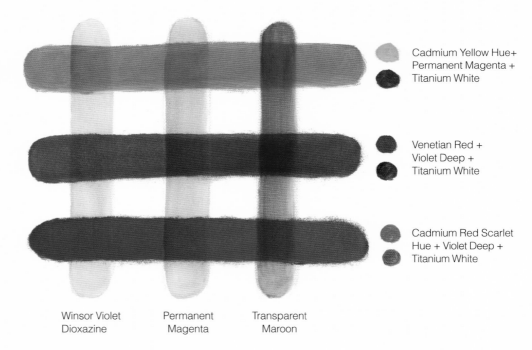

Cadmium Yellow Hue+ Permanent Magenta + Titanium White

Venetian Red + Violet Deep + Titanium White

Cadmium Red Scarlet Hue + Violet Deep + Titanium White

Winsor Violet Dioxazine

Permanent Magenta

Transparent Maroon

WARM SKIN TONES

Warm skin tones range from palest cream through deep honey to rich browns. There can be a subtle underlying golden hue. Try mixing various yellows with reds or magentas.

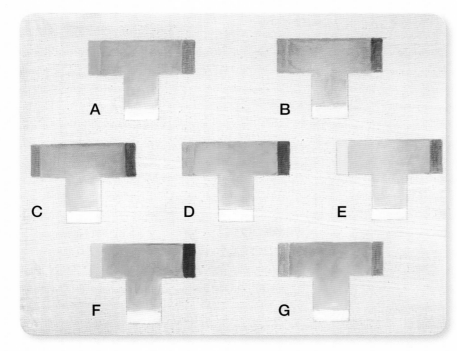

Opaque Chart of Triads

Mixing different yellows with different reds and purples yields believable warm skin tones. Yellow and red make orange, and yellow and purple make a neutral brown. Adding Titanium White to these mixtures cools them and makes them more suited for flesh tones.

A. Cadmium Yellow Hue + Rose Madder Genuine + Titanium White
B. Yellow Ochre Pale + Transparent Maroon + Titanium White
C. Cadmium Red Scarlet Hue + Winsor Blue (Green Shade) + Titanium White
D. Indian Yellow Deep + Terra Rosa + Titanium White
E. Naples Yellow Light + Burnt Sienna + Titanium White
F. Bismuth Yellow + Venetian Red + Titanium White
G. Green Gold + Cadmium Red Scarlet Hue + Titanium White

Glaze and Scumble Chart

Glazes or scumbles can work well over warm skin. Here are some examples. Notice how the yellow glaze warms and the white scumble cools the underlying colors.

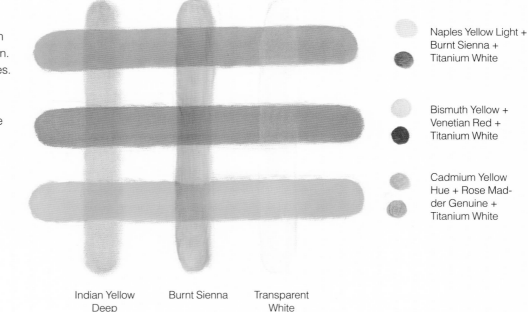

Naples Yellow Light + Burnt Sienna + Titanium White

Bismuth Yellow + Venetian Red + Titanium White

Cadmium Yellow Hue + Rose Madder Genuine + Titanium White

Indian Yellow Deep

Burnt Sienna

Transparent White

BROWN SKIN TONES

From warm amber to cool olive and deep umber, there is an enormous variety in brown skin tones. Any number of combinations might work: reds with greens, yellows with reds or blues with orange-reds.

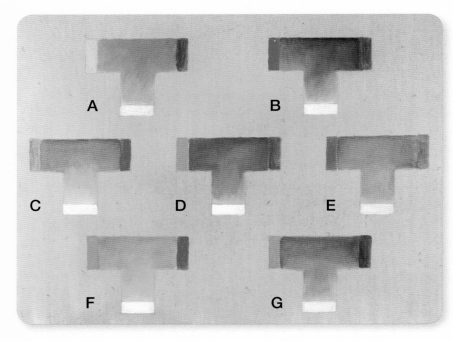

Opaque Chart of Triads

Stronger colors work well with brown skin tones. Children with Latin heritage will tend toward olive while those with Native American heritage will have a redder skin tone.

A. Bismuth Yellow + Permanent Magenta + Titanium White
B. Cadmium Red Scarlet Hue + French Ultramarine + Titanium White
C. Green Gold + Permanent Alizarin Crimson + Titanium White
D. Cadmium Yellow Hue + Venetian Red + Titanium White
E. Cadmium Red Scarlet Hue + Winsor Green + Titanium White
F. Cadmium Yellow Hue + Permanent Alizarin Crimson + Titanium White
G. Yellow Ochre Pale + Venetian Red + Titanium White

Glaze Chart

Determine if the undertone is red or green when selecting glazes or scumbles for brown skin tones. If the child has olive tones, Green Gold is a good choice. If the undertone is more red, Permanent Alizarin Crimson would work well. If the skin is neutral, Burnt Sienna will work.

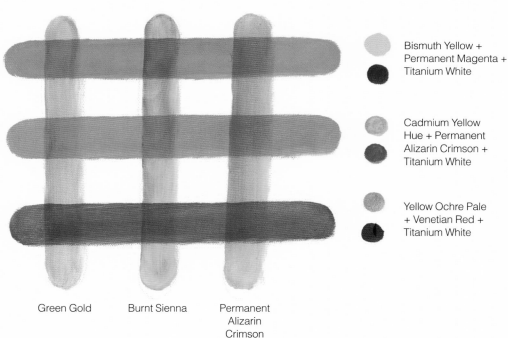

Bismuth Yellow + Permanent Magenta + Titanium White

Cadmium Yellow Hue + Permanent Alizarin Crimson + Titanium White

Yellow Ochre Pale + Venetian Red + Titanium White

Green Gold Burnt Sienna Permanent Alizarin Crimson

MIXING

In the initial stages of a portrait, mix a sufficient number of flesh values, at least five but not more than nine. You can mix more than nine skin tones, but the difference should be in hue (color) rather than value. Mix colors with a palette knife. Use more drying medium in the white paint, but a consistent amount in the other colors. The one exception is Burnt Umber, which does not need drying medium.

I usually mix many values and hues of paint for a portrait in the early and middle stages. It's time consuming, so I keep the paint in an airtight container and store it in the refrigerator between sessions.

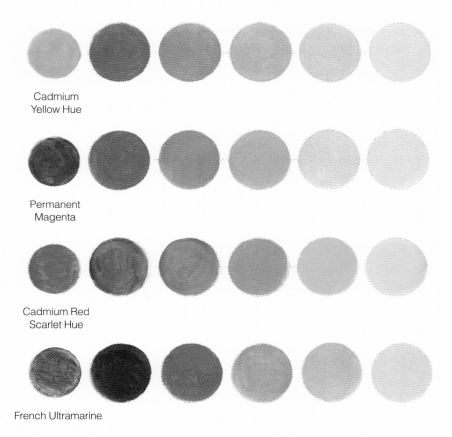

Cadmium
Yellow Hue

Permanent
Magenta

Cadmium Red
Scarlet Hue

French Ultramarine

Skin Tone Mix Chart

I used five colors to create twenty mixtures varying in value and hue.

The top two rows contain Cadmium Yellow, Permanent Magenta and Titanium White. The top row contains more Cadmium Yellow Hue than Permanent Magenta, making a slightly more yellowish skin tone, while the second row contains slightly more Permanent Magenta than Cadmium Yellow Hue, making a slightly more pinkish skin tone.

The bottom two rows contain Cadmium Red Scarlet Hue, French Ultramarine and Titanium White. The third row contains slightly more Cadmium Red Scarlet Hue than French Ultramarine, making a more reddish skin tone, while the fourth row contains slightly more French Ultramarine, making a bluer skin tone.

In all the rows, as you move toward the right, each mixture has progressively more Titanium White. You can mix many more shades from these colors. This would be a minimum.

COLOR VARIATION OF FEATURES

All skin tones have areas that are more reddish or more blue. Creased areas such as the inside of ears, nostrils and between fingers reflect light, which gives them a reddish hue. The thinner skin of the temples, eyelids and wrists often has a bluish or violet cast because blood veins show through transparent skin layers.

Cheeks, fingers, noses and ears are often more pink or red due to weather exposure. The amount of sun exposure a

child has produces deeper skin tones. Cadmium Red Scarlet Hue is particularly effective for redder areas.

Highlights are important as they give skin dimension and describe the form. It may be necessary to warm the Titanium White highlight color with Cadmium Red Scarlet Hue or Cadmium Yellow Hue.

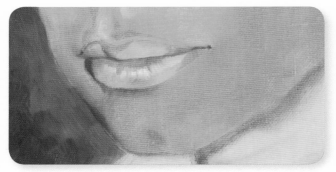

Lips Before Blending
Before blending, it is easy to see the separate colors: Cadmium Red Scarlet Hue and Transparent Maroon in the shadows, and Titanium White with a touch of Cadmium Red Scarlet Hue for the highlights.

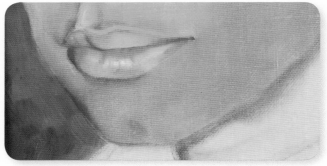

Blended Lips
After blending, the Cadmium Red Scarlet Hue, Transparent Maroon and Titanium White are still visible, but they are softly blended in.

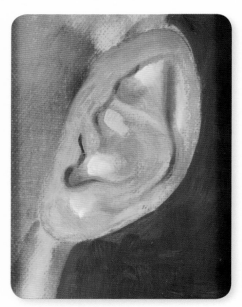

Ears Before Blending
The same process works with ears. Here they are before blending. Cadmium Red Scarlet Hue is in the creases. Titanium White is in the highlights. Use miniatures in the tight areas.

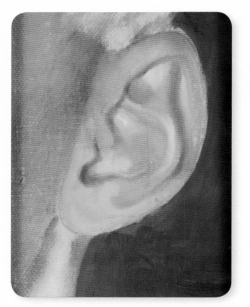

Blended Ears
After blending, the colors have been softened. A no. 6 glazing brush works well for this.

TIPS ON SKIN TONE

It's important to recognize the enormous variation in skin tones. I find it helps to select two different triad combinations and use both throughout the early stages of the painting. Then subtly vary the skin even more with selective glazes and scumbles. Different areas of the face may require different colored glazes and scumbles. Here are a few more tips to keep in mind:

• **Glazes and scumbles:** Glazes darken the skin. Scumbles lighten and cool the skin. If you are planning to glaze, make the underlayers lighter. If you are planning to scumble, make the skin darker and warmer underneath.

• **Charts:** It is extremely useful to make your own charts. Use your own rather than one from this book because printing can never mimic the natural color of paint.

• **Isolating color:** Use the same hole-punched, card-stock cards that you used to isolate value (see page 48) to isolate color (see illustrations below).

• **Mixing palettes:** The same color combinations often work for children of different ethnic backgrounds. It's all in the mixing of value and temperature. Even though I stick to a limited palette, my technique involves a great deal of mixing to get a wide range of values and colors.

• **Experiment:** Don't limit yourself to the color combination suggestions. Experiment on your own. Use the colors you already have and see what they will do.

• **Layering:** If you have the patience, you can use multiple glazes and scumbles. I'm impatient, so I usually use just a little scumbling and glazing to finish off the painting.

Isolating Color With Hole-Punched Cards
To select a color, place one hole-punched card on your reference photo, then place another card with a hole punch on the skin tone chart. Do this on different areas of the face since warm and cool temperatures can change from sunlit areas to shadow areas. Laminate your cards for durability.

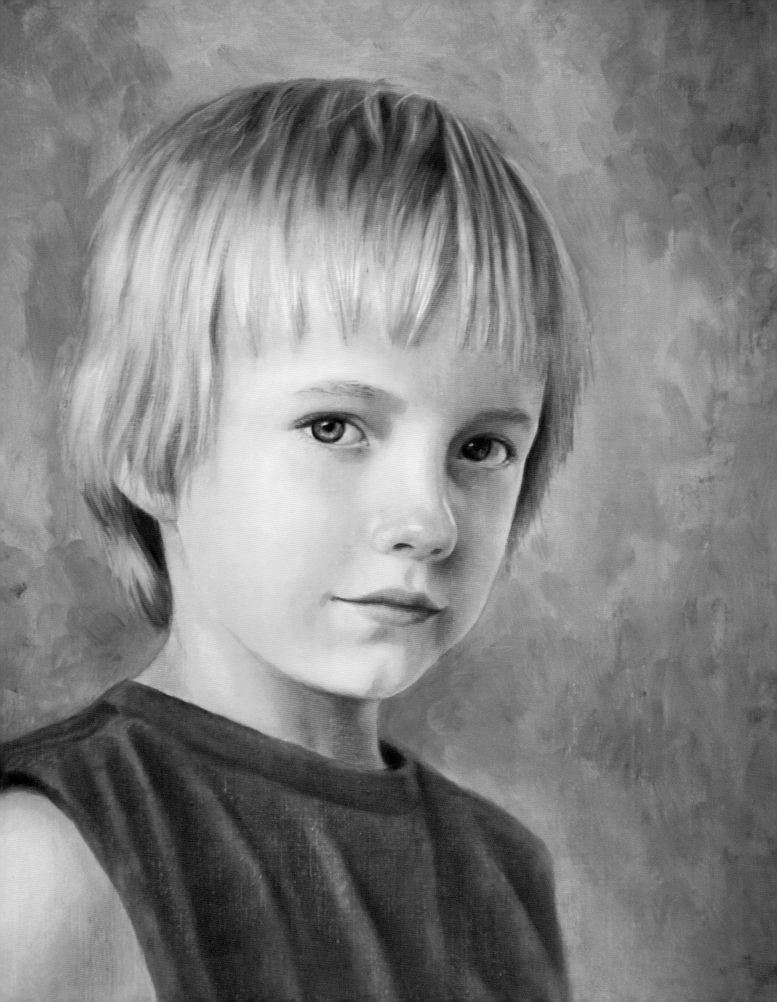

CHAPTER FIVE
HAIR

Hair is one of the more challenging things to paint convincingly in portraiture. A common mistake is to paint lots of lines without indicating the highlights and shadows. Even if you had a year to spend on it, you couldn't paint every strand since you can't paint lines as fine as a human hair. Also, hair can be very shiny with bright highlights and strong shadows. Simplify by painting the basic form of the head of hair and the patterns of light and dark. Sometimes this is difficult to analyze. This chapter will give you some practice. Having a few specialty brushes helps, such as ¼-inch (6mm) and ½-inch (12mm) combs for straight or wavy hair and a homemade brush for curly hair.

Luke
oil on canvas
12" × 9" (30cm × 23cm)

BLOND

Many color combinations will work for blond hair. This one combines Titanium White, Cadmium Yellow Hue and Winsor Violet Dioxazine. Yellow and violet are complementary colors and make a pleasing series of values for blond hair.

Reference Photo

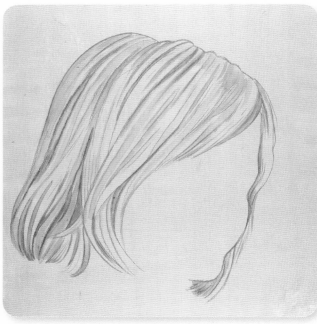

MATERIALS

Surface
gessoed canvas

Paints
Burnt Sienna (Alkyd), Burnt Umber, Cadmium Yellow Hue, Indian Yellow Deep, Permanent Alizarin Crimson, Titanium White, Winsor Violet Dioxazine

Brushes
nos. 2, 4, 6 watercolor rounds
¼-inch (6mm) comb

Other Supplies
drying medium, palette knife

1 CREATE THE UNDERPAINTING
Tone the canvas with Burnt Sienna (Alkyd). Let it dry. Paint a Burnt Umber underpainting of the hair. Use a no. 4 watercolor round and stroke in the direction of the hair. Establish the darkest and medium values. Don't worry about the light values at this stage. Let it dry.

ARTIST'S TIP

Squint your eyes when you look at your reference, not your painting. Squinting minimizes detail and helps you see value better. Don't try to paint every strand of hair—focus on the value pattern of the hair.

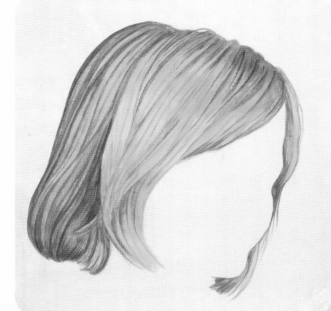

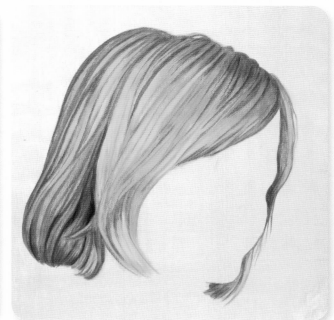

2 APPLY AN OPAQUE COAT

Lay out Titanium White, Cadmium Yellow Hue and Winsor Violet Dioxazine; stir a drop of drying medium into each color. Mix five to seven values, ranging from almost white to a violet and yellow mixture with no white. You should end up with a range of blonds through browns. Stroke the darker values first, then the mediums, then the lights. Use no. 4 watercolor round to paint and a ¼-inch (6mm) comb to blend. Let it dry. Repeat this entire step if necessary.

ARTIST'S TIP

Blond hair is tricky because it turns green if you paint a lighter blond value over a darker value. Avoid this problem by making the lighter blond streaks warm or slightly reddish.

3 ADD THE TRANSPARENT GLAZES AND HIGHLIGHTS

Lay out Titanium White, Cadmium Yellow Hue, Indian Yellow Deep, Permanent Alizarin Crimson and Burnt Umber. Mix each of the colors except Burnt Umber with a drop of drying medium.

Mix a warm golden glaze with Permanent Alizarin Crimson and Indian Yellow Deep. Indian Yellow Deep is very transparent but slightly green, so you need the red to warm it. You'll have to experiment to get a golden color. Brush this over the hair with a no. 6 watercolor round. Use a no. 2 watercolor round to work some highlights and blonder strands into the glaze with an opaque mix of Titanium White and Cadmium Yellow Hue. Clean the brush and add some dark streaks with Burnt Umber.

HAIR DEMONSTRATION
RED

There are many shades of red hair, including strawberry blond, titian, auburn and carrot colored. In addition, many different hues are visible on one head of hair, varying from the lightest highlights to the deepest shadows. Study your reference and determine how many different shades of red you see. For most redheads a blend of yellow and red, such as Cadmium Yellow Hue and Permanent Alizarin Crimson, will be more convincing than Cadmium Orange Hue. However, some redheads have very carroty-colored hair, so Cadmium Orange Hue would be a good choice.

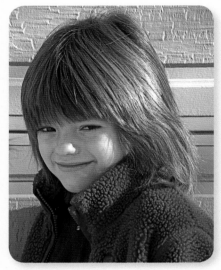

Reference Photo

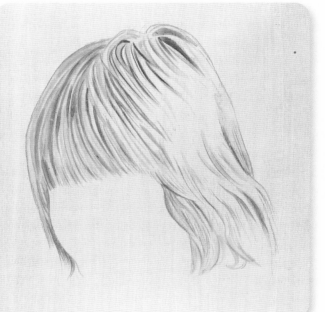

MATERIALS

Surface
gessoed canvas

Paints
Burnt Sienna (Alkyd), Burnt Umber, Cadmium Yellow Hue, Indian Red, Indian Yellow Deep, Permanent Alizarin Crimson, Permanent Magenta, Titanium White

Brushes
no. 2 short filbert
nos. 4, 6 watercolor rounds
½-inch (12mm) comb

Other Supplies
drying medium, solvent

1 CREATE THE UNDERPAINTING
Paint a thin coat of Burnt Sienna (Alkyd) over the canvas. Let it dry. With a no. 4 watercolor round and a no. 2 short filbert, paint the underpainting with Burnt Umber. Stroke in the direction of the hair flow and establish the values.

2 APPLY AN OPAQUE COAT

Lay out Titanium White, Cadmium Yellow Hue and Permanent Magenta; stir a drop of drying medium into each one. Mix six or seven values from these colors. Using the same brushes, add the dark values first, then the mediums, then the lights. Stroke in the direction of the hair flow. Use a ½-inch (12mm) comb to smooth the hair. Let it dry.

ARTIST'S TIP

Many colors will make for interesting reds. Mix Cadmium Red Scarlet Hue and Cadmium Yellow Hue for a brighter red, or use Burnt Sienna or Venetian Red with Burnt Umber for a more subdued red.

3 ADD THE TRANSPARENT GLAZING AND HIGHLIGHTING

Lay out Titanium White, Cadmium Yellow Hue, Burnt Umber, Indian Red, Indian Yellow Deep and Permanent Alizarin Crimson; stir in a drop of drying medium with each color (except for Burnt Umber, which does not require medium).

Mix Indian Yellow Deep and Permanent Alizarin Crimson to create a warm reddish gold. Brush this over the hair with a no. 6 watercolor round. Mix Titanium White and Cadmium Yellow Hue for highlights. Work a dark reddish mixture of Burnt Umber and Permanent Alizarin Crimson into the darkest areas. Add a few lighter strands with the white/yellow mix if necessary.

HAIR DEMONSTRATION
BLACK

If you analyze black hair closely, you'll see that it is composed of many beautiful dark shades: deep purples, burgundy, mahogany and silvery or even golden highlights. Some black hair has a reddish cast, some a blue-black tone. This can vary according to the light and time of day. Study your reference carefully and see how many colors and values you can identify.

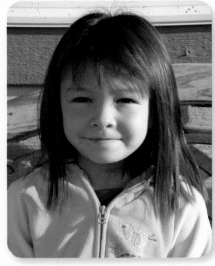

Reference Photo

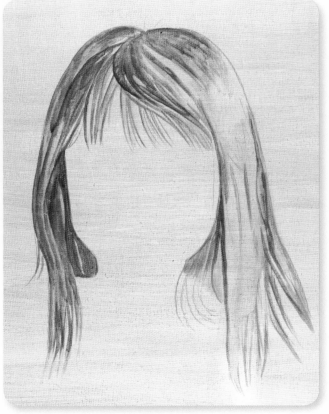

MATERIALS

Surface
gessoed canvas

Paints
Burnt Sienna (Alkyd), Burnt Umber, Cadmium Red Scarlet Hue, Cadmium Yellow Hue, Permanent Magenta, Titanium White, French Ultramarine

Brushes
no. 2 short filbert
no. 4 watercolor round
½-inch (12mm) comb

Other Supplies
drying medium, palette knife

1 CREATE THE UNDERPAINTING
Tone the canvas with a Burnt Sienna (Alkyd) glaze. Let it dry. Use Burnt Umber to paint in the values of the hair. Use a no. 2 short filbert and a no. 4 watercolor round. Stroke in the direction of the hair flow. Let it dry.

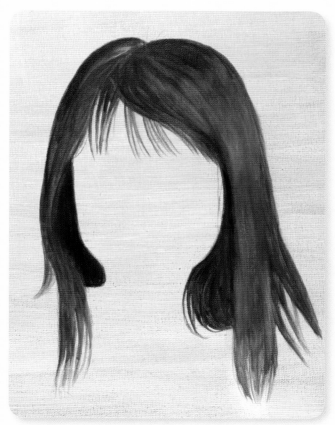

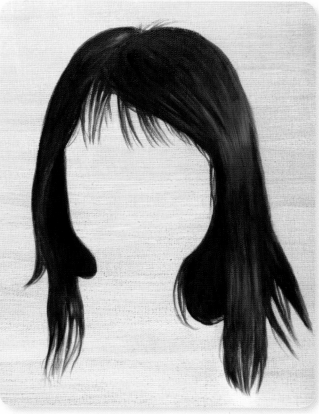

2 APPLY AN OPAQUE COAT

Lay out Titanium White, Cadmium Red Scarlet Hue and French Ultramarine; stir in a drop of drying medium with each one. Mix seven values from these colors. Do not add white to the darkest values. Make one dark value more red and one more blue. Using the same brushes as in step 1, stroke in the values starting with the darkest. Vary the darks from redder to bluer to add interest. Use the ½-inch (12mm) comb to blend the hair. Let it dry.

3 ADD THE TRANSPARENT GLAZES AND HIGHLIGHTS

Lay out Permanent Magenta, French Ultramarine, Cadmium Yellow Hue and Titanium White; stir in a drop of drying medium with each. Mix Permanent Magenta and French Ultramarine into a couple of shades of purple. Glaze these two colors over the hair, varying the shades. Mix yellow and white for a highlight color and work it in the lightest areas. Don't overdo the lightest highlights. Work a little Burnt Umber into the darkest areas.

ARTIST'S TIP

Using black straight from the tube in excess can suck the life out of a painting. It's better to mix your blacks using opposite colors of strong hue. You can use a small amount of pure black accents, but too much creates an unpleasant effect.

HAIR DEMONSTRATION
DARK BROWN

Simply using a brown tube of paint to paint dark brown hair will yield very boring results. Dark brown hair has many subtle colors, including mahogany, maroon, blond and even purple. Some dark brown hair tends more toward red while others more toward blue. This can vary with the lighting. Study your reference carefully to see how many shades you can pick out. In addition, dark brown hair can be very shiny with bright, almost white highlights.

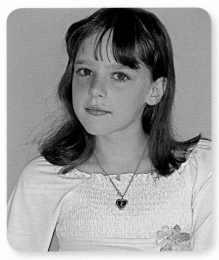

Reference Photo
Photo by Jane Maday

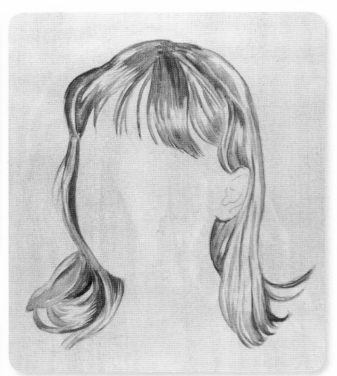

MATERIALS

Surface
gessoed canvas

Paints
Burnt Sienna (Alkyd), Burnt Umber, Cadmium Yellow Hue, French Ultramarine, Indian Yellow Deep, Permanent Alizarin Crimson, Titanium White, Transparent Maroon, Venetian Red

Brushes
no. 2 short filbert
nos. 4, 6 watercolor rounds
½-inch (12mm) comb

Other Supplies
drying medium, palette knife

1 CREATE THE UNDERPAINTING
Tone the canvas with Burnt Sienna (Alkyd). Let it dry. Paint a Burnt Umber underpainting. Use a no. 2 short filbert and a no. 4 watercolor round, stroking in the direction of the hair flow. Establish the values as accurately as possible. Let it dry.

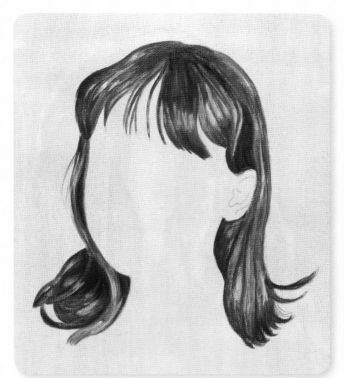
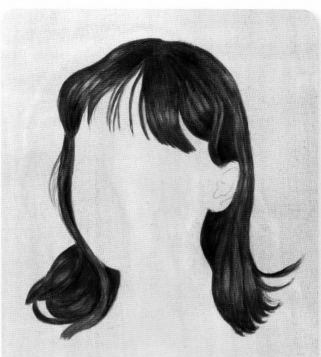

2 APPLY AN OPAQUE LAYER
Lay out Venetian Red, French Ultramarine and Titanium White; stir in a drop of drying medium with each. Mix five to seven values with these colors. Omit white from the darkest mix. Starting with the dark values, paint in the shadows, then the medium tones, then the lights. Use a no. 2 filbert and a no. 4 watercolor round, stroking in the direction of the flow. Let it dry.

3 ADD THE TRANSPARENT GLAZES AND HIGHLIGHTS
Lay out Titanium White, Indian Yellow Deep, Permanent Alizarin Crimson, Transparent Maroon and Cadmium Yellow Hue; stir in a drop of drying medium with each. Mix Indian Yellow Deep and Permanent Alizarin Crimson to create a transparent gold. Brush this over the lighter areas of hair. Brush Transparent Maroon over the darker areas. Add a few highlights and strands of lighter hair with a mix of Titanium White and Cadmium Yellow Hue. Paint the dark areas with more Transparent Maroon. Use nos. 4 and 6 watercolor rounds. Blend with a ½-inch (12mm) comb, stroking it in the direction of the hair flow. Reinforce the darkest areas with Burnt Umber.

ARTIST'S TIP

Think of shiny, wavy hair as ribbons. It has highlights and shadows as it turns in and out of the light.

HAIR DEMONSTRATION
LIGHT BROWN

If you study light brown hair, you will see that it encompasses a range of colors, from blond in the highlights to mahogany in the shadows. Light brown hair will get sun-bleached to blond or even light blond on the outer layers and remain a darker brown on the inner layers.

Reference Photo

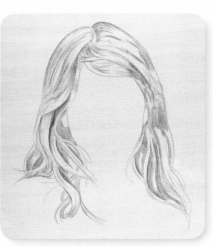

1 CREATE THE UNDERPAINTING
Tone the canvas with Burnt Sienna (Alkyd). Let it dry. Paint a Burnt Umber underpainting, using a no. 2 short filbert and a no. 4 watercolor round. Use a ¼-inch (6mm) comb to blend the values. Represent the values as closely as possible. Let it dry.

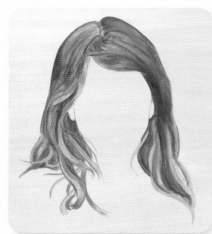

2 APPLY AN OPAQUE COAT
Lay out Titanium White, Yellow Ochre Pale and Burnt Umber. Mix the first two colors with a drop of drying medium. Mix five to seven values with these colors to create dark blond through dark brown. Paint these over the underpainting, matching the values as closely as possible. Use the same brushes as in step 1, stroking in the direction of the hair flow.

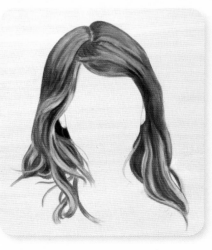

3 ADD THE TRANSPARENT GLAZES AND HIGHLIGHTS
Lay out Burnt Sienna, French Ultramarine, Cadmium Yellow Hue and Titanium White; mix a drop of drying medium into each color. Make a brown glaze with Burnt Sienna and French Ultramarine, and brush it over the hair with a no. 2 filbert. Work in a few highlights with a mix of Titanium White and Cadmium Yellow Hue. Reinforce the darkest areas with a touch of Burnt Umber.

BACKLIT HAIR

Although it's more challenging and time consuming, backlit hair can look lovely in a portrait painting. To paint backlit hair, add a darker background to make the highlighted strands stand out. Make individual strands thin, flowing and random. Thin the paint with solvent and think before placing the strands. The unconscious tendency is to make them too evenly spaced, which looks unrealistic.

<div style="float:right">

MATERIALS

Surface
gessoed canvas

Paints
Bismuth Yellow, Burnt Sienna, Burnt Sienna (Alkyd), Burnt Umber, Permanent Magenta, Titanium White, Violet Deep, Yellow Ochre Pale

Brushes:
nos. 2, 4 filberts
no. 4 watercolor round
½-inch (12mm) comb
no. 3 miniature

Other Supplies
drying medium, palette knife

</div>

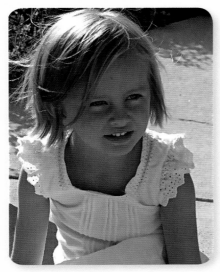

Reference Photo

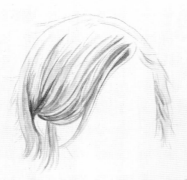

1 CREATE THE UNDERPAINTING
Tone the canvas with Burnt Sienna (Alkyd) and let it dry. Apply a Burnt Umber underpainting, using a no. 4 watercolor round and a no. 2 filbert to establish the darks. Let it dry.

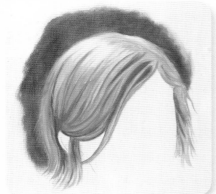

2 APPLY AN OPAQUE COAT
Lay out Titanium White, Bismuth Yellow, Permanent Magenta, Yellow Ochre Pale and Violet Deep; stir a drop of drying medium into each color. Mix eight or more values. Use only Yellow Ochre Pale and Violet Deep in the darkest values. Starting with the lightest values, place the colors. Use a ½-inch (12mm) comb to blend. Make a purplish brown with Violet Deep, Titanium White and Yellow Ochre Pale, and paint the background.

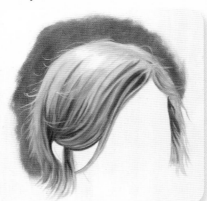

3 ADD THE TRANSPARENT GLAZES AND HIGHLIGHTS
Lay out Burnt Sienna, Bismuth Yellow and Titanium White; mix a drop of drying medium into each. Brush a glaze of Burnt Sienna and Bismuth Yellow over the hair, except for the lightest highlights, using a no. 4 filbert. Mix Titanium White and Bismuth Yellow in several light values for highlights. Brush them in using a no. 4 watercolor round. Use a no. 3 miniature for the smallest strands against the background.

STRAIGHT

Straight hair is the easiest hair texture to paint because the hair falls in a straight line following the shape of the head. Also, there is less overlap of hairs, so it's easier to analyze the basic form of the head. Straight hair usually has a lot of shine with broader highlights and shadows.

MATERIALS

Surface
gessoed canvas

Paints
Burnt Sienna, Burnt Sienna (Alkyd), Burnt Umber, Cadmium Red Hue, Cadmium Yellow Hue, Naples Yellow Light, Transparent Maroon, Venetian Red

Brushes
no. 2 short filbert
nos. 0, 6 watercolor rounds
no. 3 miniature
½-inch (12mm) comb

Other Supplies
drying medium, palette knife, red watercolor pencil

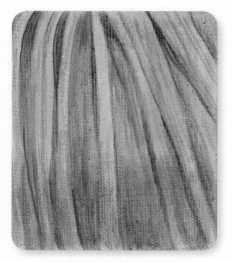

1 CREATE THE UNDERPAINTING
Draw the hair with a red watercolor pencil. Then tone the canvas with Burnt Sienna (Alkyd). Over this, paint the values with a mix of Burnt Sienna and Burnt Umber. Use nos. 0 and 6 watercolor rounds, stroking in the direction the hair flows. Straight hair follows the shape of the head very closely, so you can see the underlying form of the skull.

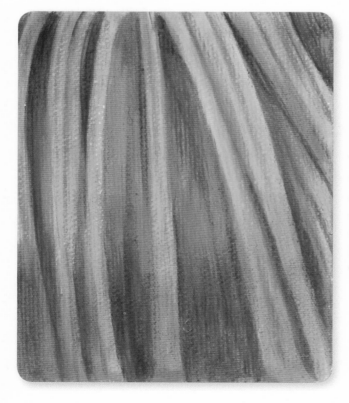

2 ADD AN OPAQUE COAT
Obviously any colors can be used for straight hair. The ones I used for this demo include Naples Yellow Light, Cadmium Yellow Hue, Cadmium Red Hue, Venetian Red and Transparent Maroon. Mix a drop of drying medium into each. Mix a range of colors from light to dark red. Use a no. 2 short filbert to stroke on the colors, starting with the lightest. Add fine details with a no. 3 miniature. Blend lightly with a ½-inch (12mm) comb.

WAVY

Wavy hair is a bit more challenging than straight hair because there are many smaller shapes within the overall form of the hair. Each of these strand shapes will have a lit area and a shadow area as well as cast shadows on the hair behind it. Analyze this very carefully. Accurate drawing is important.

MATERIALS

Surface
gessoed canvas

Paints
Burnt Sienna, Burnt Sienna (Alkyd), Burnt Umber, Cadmium Red Hue, Cadmium Yellow Hue, Naples Yellow Light, Titanium White

Brushes
nos. 0, 4, 6 watercolor rounds
no. 3 miniature
½-inch (12mm) comb

Other Supplies
drying medium, palette knife, red watercolor pencil

1 CREATE THE UNDERPAINTING
Draw the hair with a red watercolor pencil, then apply Burnt Sienna (Alkyd) with nos. 0 and 6 watercolor rounds. Wavy hair curves and the strands overlap, which produces shadows on the underlying hair. Work carefully with a Burnt Umber and Burnt Sienna mix to record the shapes and shadows.

2 APPLY AN OPAQUE COAT
Any colors can be used to paint wavy hair. In this demo I used Titanium White, Naples Yellow Light, Cadmium Yellow Hue, Burnt Umber and Cadmium Red Hue, mixing each with a drop of drying medium. Mix six values ranging from pale blond to dark brown. Using a no. 4 watercolor round, start with light values and move to dark. Use a no. 3 miniature for the darkest values. Use a ½-inch (12mm) comb to blend. Once dry, restate the darkest and lightest values with a no. 3 miniature.

HAIR DEMONSTRATION
CURLY

The curlier the hair, the more complex the shapes that lie within the overall hair shape. This makes curly hair more of a challenge. Rather than trying to paint every strand, use a modified fan brush to create the textural effect of curly hair.

1 CREATE THE UNDERPAINTING
Glaze the canvas with a Burnt Sienna (Alkyd) and let dry. Paint the Burnt Umber underpainting using a splayed brush (see below). Curly hair is the most challenging because so many hairs overlap. Use the splayed brush to paint the darker color and overlap the layers.

MATERIALS

Surface
gessoed canvas

Paints
Burnt Sienna (Alkyd), Burnt Umber, Cadmium Red Hue, French Ultramarine, Mars Black, Naples Yellow Light, Titanium White, Transparent Maroon, Venetian Red

Brushes
no. 4 filbert
no. 4 watercolor round
nos. 0, 3 miniatures
no. 6 glazing brush
homemade fan/splayed brush

Other Supplies
drying medium, fine detail drying medium, palette knife

CREATING A SPLAYED BRUSH

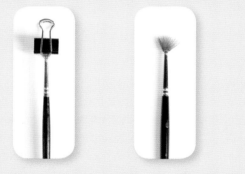

Use a clothespin or clamp to splay the bristles of a worn-out round. Place a drop of acrylic medium at the base of the brush. Let it dry.

This produces a brush that is a little more irregular than a comb or fan brush. Its worn, irregular ends create more natural-looking strands for very curly hair.

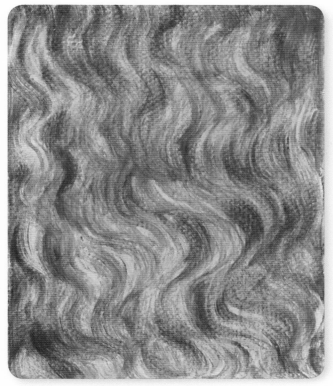

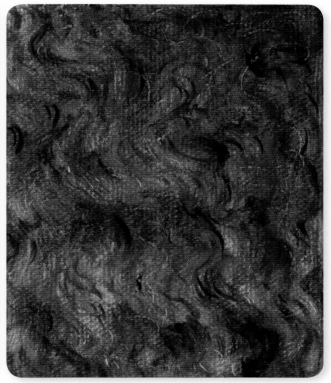

2 APPLY AN OPAQUE COAT

Lay out Titanium White, Naples Yellow Light, Cadmium Red Hue, Venetian Red, Transparent Maroon and French Ultramarine; mix a drop of drying medium into each. Create a range of six values from dark blond to dark brown. Using a no. 4 filbert, stroke a thin medium shade over the entire rectangle. With a no. 4 watercolor round and the splayed brush, stroke on darker shades, following the wavy shapes of the hair. Strands of curly hair have a ribbonlike look. The individual waves move in and out of shadow.

Once dry, restate the darkest and lightest values with the same paint mixes and a no. 3 miniature.

3 ADD THE TRANSPARENT GLAZES AND HIGHLIGHTS

Mix a drop of fine detail drying medium with each of the colors in this step. Mix French Ultramarine with Transparent Maroon to create two rich darks, one with more Transparent Maroon and one with more French Ultramarine. Use a no. 4 filbert to brush these two colors thinly over the entire hair, varying the warmer and cooler darks. Put the warmer color more on the right and the cooler color more on the left. Use the homemade fan to indicate individual strands. Add a few more strands with a no. 3 miniature. If the hair looks too coarse, gently blend it with a no. 6 glazing brush.

For the darkest shadows, add Mars Black sparingly with a no. 3 miniature. For even darker hair, let it dry then reglaze with Transparent Maroon and French Ultramarine as before. Use the end of the handle to scratch in a few lighter, curly strands.

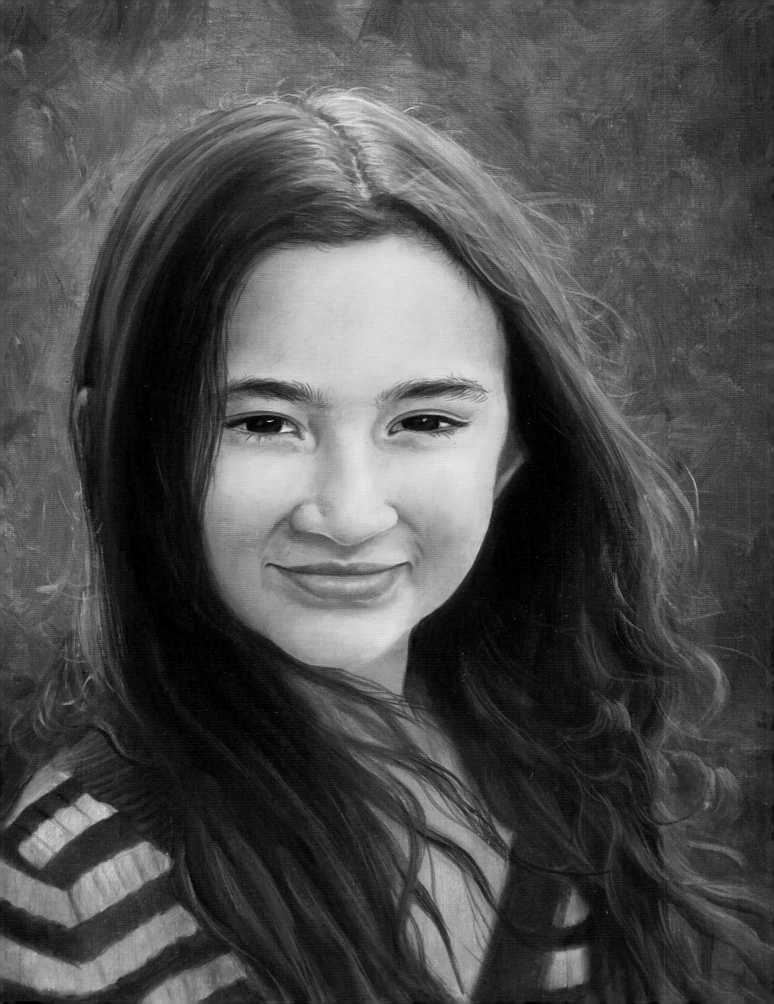

CHAPTER SIX
PORTRAITS

The following step-by-step demonstrations should get you started on painting children's portraits. The first demonstration has fourteen steps that outline the painting process in great detail. The other ten demonstrations have been condensed to just six steps.

The painting process in each demonstration is essentially the same: create a careful drawing, establish the values, add color, then finish with fine details and refinements. This method allows you to concentrate on one aspect at a time, which is much easier than trying to do everything at once.

Take your time with the steps and remember that most paintings go through ugly-duck phases, so don't get discouraged. If you get the drawing right, then the values, then the color, the finishing process will be rewarding.

Everyone's painting style is unique. Approach the step-by-step demonstrations with this in mind. If you find values and/or color very easy and establish them quickly, a second coat may be unnecessary. If you paint very thinly and delicately, you may need to repeat a step to bring the values and colors up. Learn to evaluate your own painting and proceed accordingly.

Emma
oil on canvas
14" × 11" (36cm × 28cm)

LIGHT SKIN AND HONEY BLOND HAIR

The mischievous expression in this little boy's dark eyes balances his angelic appearance. His peaches-and-cream complexion is set off by his streaky blond hair. Notice all the different shades of blond and the way his hair falls and frames his face. The V-neck of his jacket makes for a nice composition element that leads directly to his face.

Reference Photo

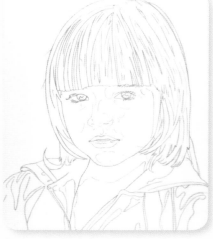

1 DRAW ON TRACING PAPER
When drawing for painting, use lines to show where shadows change value and colors change temperature. Make a line drawing, paying attention to subtle changes in temperature and value. Try to record all the major changes in value in his hair.

ARTIST'S TIP

After you've finished the drawing on tracing paper, flip it over to study the reverse image (or hold it up to a mirror). Errors will be more obvious. Go through a checklist:
- Are the eyes aligned?
- Are the eyes looking in the same direction?
- Is the width between the eyes correct?
- Are the eyes placed at the right level?
- Are the lips symmetrical?
- Are the features rounded?

MATERIALS

Surface
12" × 9" (30cm × 23cm) gessoed canvas

Paints
Burnt Sienna (Alkyd), Burnt Umber, Cadmium Red Hue, Cadmium Red Scarlet Hue, Cadmium Yellow Hue, French Ultramarine, Indian Yellow Deep, Mars Black, Naples Yellow Light, Permanent Alizarin Crimson, Permanent Magenta, Titanium White, Transparent Maroon

Brushes
1-inch (25mm) and nos. 4, 6, 12 flats
no. 2 short filbert
nos. 4, 12 filberts
no. 4 watercolor round
nos. 000, 3 miniatures
no. 6 glazing brush
no. 4 fan
½-inch (12mm) comb

Other Supplies
drying medium, fine detail drying medium, gesso, gray scale, hem gauge, palette knife, paper towels, HB pencil, red transfer paper, red or gray watercolor pencil, sandpaper, solvent, tack cloth, tracing paper

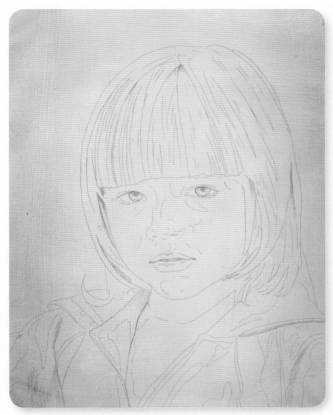

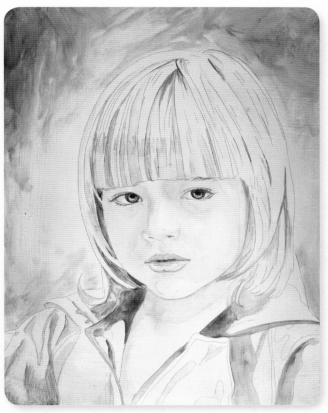

2 TONE THE CANVAS AND TRANSFER THE DRAWING

Sand the canvas very lightly with fine sandpaper. Wipe it clean with a tack cloth. With a 1-inch (25mm) flat, apply a thin additional coat of gesso. Let it dry thoroughly and sand again. Wipe all the dust off with the tack cloth.

Brush a thin coat of Burnt Sienna (Alkyd) on the surface with the 1-inch (25mm) flat. Smooth out the area where the face will be with a paper towel. Let it dry thoroughly.

Tape the tracing over the canvas securely. Slide a sheet of red or gray transfer paper underneath. Red transfer paper is preferable, but gray will do. Using an HB pencil, transfer the image. Reinforce any areas you missed with a red or gray watercolor pencil.

3 CREATE THE UNDERPAINTING

Mix Burnt Umber with a touch of solvent and paint the values. Use a no. 3 miniature like a fine pencil. Use a no. 2 short filbert to blend, scrubbing and softening the shadows. Use a no. 4 watercolor round for the hair. Lift paint when necessary with a paper towel. As you work, lift off any red or gray pencil lines that are too prominent with solvent, scrubbing with the no. 2 short filbert. Fill in the shadows. Your goal is a graded image without harsh lines.

Take your time. The underpainting is the backbone of the painting. If you have any doubts, remeasure with the hem gauge. When you are satisfied with the portrait, brush in some background shading with a no. 12 filbert. Let it dry completely.

ARTIST'S TIP

Place your reference right next to your painting. I attach my photo to a board with a clamp and perch it on the easel next to the painting.

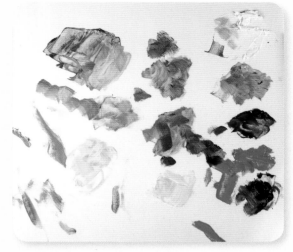

4 MIX THE COLORS FOR THE BACKGROUND

Lay out Titanium White, Cadmium Yellow Hue, Permanent Magenta, Cadmium Red Hue and French Ultramarine. Add a drop of drying medium to each color and mix in thoroughly with a palette knife.

Mix Titanium White, Cadmium Yellow Hue, Permanent Magenta and French Ultramarine to make a couple of shades of tan. Mix Titanium White, Cadmium Yellow Hue and French Ultramarine to make a couple of greens. Avoid overmixing the paint.

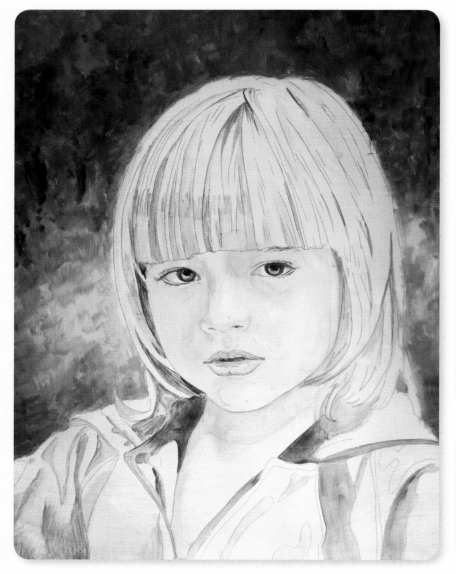

5 PAINT THE BACKGROUND

Use a no. 12 flat to paint the background, mixing mostly on the canvas. Use a no. 6 flat when working closer to the boy's head. Clean the brush with a paper towel when you want a pure touch of color. When you are satisfied, blend ever so slightly with a no. 4 fan. Let it dry thoroughly.

ARTIST'S TIP

Drying medium makes the paint dry faster. Either mix a new batch of paint every day or refrigerate your colors in a tight sealed plastic container. Partly dried out paint is hard to blend and frustrating to work with.

ARTIST'S TIP

To steady your hand, use a mahlstick or long dowel, especially when painting the eyes, nose and mouth.

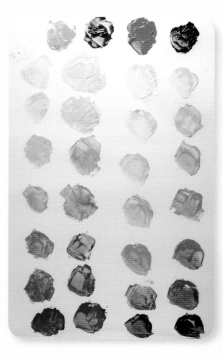

6 MIX THE SKIN PALETTE

The object of the next two steps is to establish the values. It's easier if you mix a lot of them first. Lay out Titanium White, Cadmium Yellow Hue, Permanent Magenta, Cadmium Red Hue and French Ultramarine; stir a drop of drying medium into each color. Use a little extra medium with the Titanium White since it dries the slowest.

Mix twenty-eight colors and values: Start with two mixtures of Cadmium Yellow Hue and Permanent Magenta together, one with more yellow and one with more magenta. Make six more values from each, adding progressively more Titanium White. You should have seven values of a redder mix and a yellower mix. Do the same with Cadmium Red Hue and French Ultramarine.

In addition, mix three values of blue-gray with French Ultramarine, Titanium White and a touch of Cadmium Red Hue for the whites of the eyes.

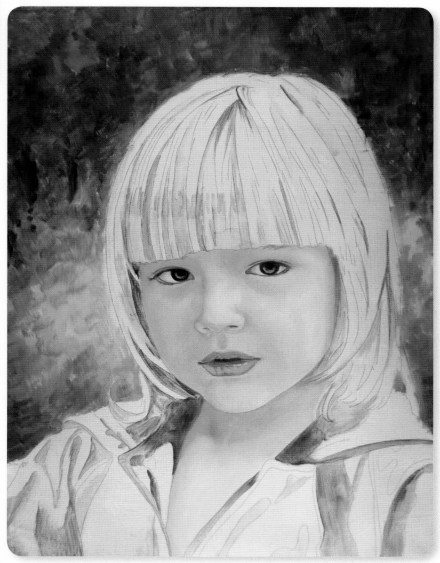

7 PAINT THE SKIN

Use a gray scale to place the values. Lay it on the reference first, then select the correct values. Place the darker values on the canvas, using a no. 2 short filbert. Then add progressively lighter values. Place graduated values next to each other. For the smallest details use a no. 3 miniature. Blend with a no. 6 glazing brush.

Use a no. 3 miniature for the whites of the eyes with the blue mixes from step 6, checking the values with the gray scale. Paint the irises, pupils and lash line with the darkest mix of Cadmium Red Hue and French Ultramarine. Use a redder mix in the creases. Paint the base of the eyelashes with the dark mix. Make sure the irises are round and symmetrical.

Use a no. 3 miniature for the lips with mixes that have more Cadmium Red Hue. Paint the inside of the mouth with the darkest red-blue mixture (more to the red). Blend with a no. 6 glazing brush.

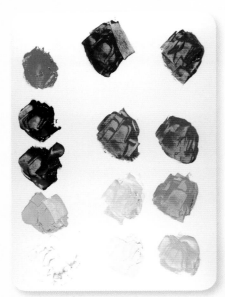

8 MIX THE HAIR PALETTE

Lay out Titanium White, Cadmium Yellow Hue, Permanent Magenta, French Ultramarine and Cadmium Red Scarlet Hue; mix a drop of drying medium into each color. Make at least eight values from these colors. For the lightest blond color, mix Titanium White with a touch of Cadmium Yellow Hue. For the next darker shade, add a touch of Permanent Magenta and more Cadmium Yellow Hue. Add more Cadmium Yellow Hue and Permanent Magenta for the next two darker shades. Make two darker shades with the same colors but with less Titanium White and a touch of French Ultramarine. For the darkest shade, mix Cadmium Red Scarlet Hue and French Ultramarine (no white). Make a slightly lighter shade with Cadmium Red Scarlet Hue, French Ultramarine and Cadmium Yellow Hue.

9 PAINT THE HAIR

Paint the darkest colors first, then the medium, then the lightest colors. Use a no. 2 short filbert and a no. 6 flat. Use a no. 3 miniature for the finest details. After the basics are in, add more details with a no. 4 watercolor round. Always stroke the brush in the direction the hair flows. Pay attention to the shading on the head. The lightest color is only on the highlights. Blend a little with the flat, but keep some contrast. Hair needs much less blending than skin. The finish should be slightly redder and warmer than you intend since in a later stage scumbling will make the colors tend toward gray or green.

ARTIST'S TIP

It's better to create your own mixtures rather than using colors straight from the tube because a limited palette unifies and harmonizes a painting.

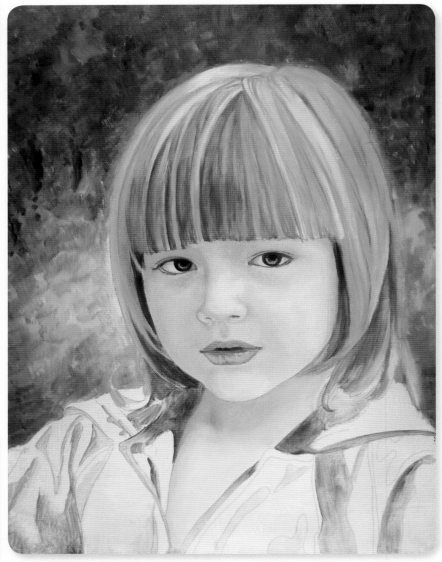

10 MIX THE CLOTHES PALETTE
Use the same colors you have used already, mixing each with a drop of drying medium.

Mix Cadmium Yellow Hue with Titanium White for the lightest yellow. Add Permanent Magenta and French Ultramarine to Cadmium Yellow Hue for medium and darker values.

Mix Titanium White with Permanent Magenta and a touch of Cadmium Red Hue for a very light burgundy. Mix Permanent Magenta with a touch of Cadmium Red Scarlet Hue for medium burgundy. Mix Permanent Magenta, French Ultramarine and a touch of Cadmium Red Scarlet Hue for the darkest burgundy.

Mix French Ultramarine with a touch of Titanium White and Cadmium Red Scarlet Hue for a medium blue. Add more Titanium White for the lightest blue. Mix French Ultramarine and a touch of Cadmium Red Scarlet Hue (no white) for the darkest blue.

11 PAINT THE CLOTHES
Starting with yellow, paint the lightest value with a no. 2 short filbert. Add the darker values with a no. 3 miniature. Add a little Cadmium Red Scarlet Hue in the shadow areas for reflected light.

Next, paint the burgundy area. Begin with the middle value, then the dark, then the light area. Use a no. 2 short filbert and a no. 6 flat at the darkest areas.

Paint the blue area next. Using the same brushes, paint the medium value first, then the dark and the light.

It's important to work in this color order. If you start with blue, the yellow will likely get contaminated and look green. When you are satisfied with the paint application, blend lightly with a no. 4 fan. Be careful to avoid contaminating the colors.

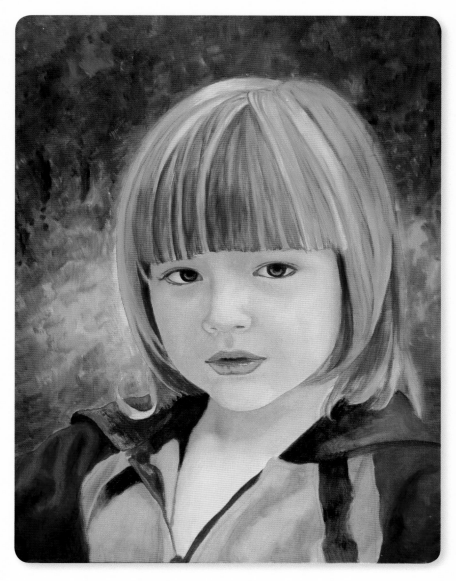

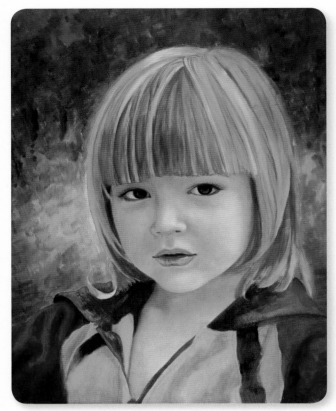

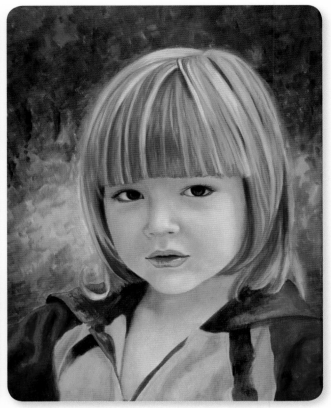

12 APPLY A SECOND COAT TO THE SKIN AND HAIR
If you are satisfied with the first coat, proceed to the final step. I usually do a second coat, especially on the skin. The goal of this step is to refine and develop the color.

Mix the same skin colors from step 6. Note where the skin is subtly more yellow (above the eyes), more red (cheeks and nose) and more blue (under the nose and under the mouth). Add a mix of Cadmium Red Scarlet Hue and Permanent Magenta to the inner part of the lower lip.

Correct any proportions that are off, paying special attention to the eyes. Use a no. 3 miniature for details.

Use a no. 2 short filbert for larger areas and a no. 6 glazing brush to soften. Paint only the areas that need adjusting.

Mix the same hair colors from step 8. Using a no. 4 watercolor round, paint the highlights with the lightest mix. Work from light to dark, stroking with the flow. Keep contrasts for the sun-bleached, streaked look. The hair will become cooler even though you're using the same colors. If the hair starts to look greenish, add some Cadmium Red Scarlet Hue. Blend lightly with a no. 4 flat. Don't overblend, since that will ruin the contrast of the streaks. Establishing some darks close to the face will draw attention there.

13 APPLY A SECOND COAT TO THE CLOTHES
Use the same colors from step 10. Repaint only those areas that need more coverage or restating. Paint the clothes more loosely than the face and hair. Follow the color sequence the same as before: yellow, then burgundy, then blue. It's OK if a little red mixes with the yellow, but be careful with the blue. Use a no. 2 short filbert and a no. 6 flat, holding the brushes more loosely as you work toward the edge of the painting. Use a no. 3 miniature at the edge where the cloth meets up with the skin and on stitch work. Make the shadows dark, but not darker than the pupils of the eyes. Add lighter colors for highlights. Let the second coat dry thoroughly.

ARTIST'S TIP

Many art teachers recommend using large brushes to keep your work loose. That's great for some parts of the painting, but the detailed realism in my portraits requires some smaller brushes with perfect tips.

14 ADD THE FINISHING TOUCHES

Lay the tracing over the painting to check for accuracy. Have any of the features gone out of alignment? Go over the checklist from page 78. Use a red watercolor pencil to reposition things.

Use Titanium White, Naples Yellow Light, Indian Yellow Deep, Permanent Alizarin Crimson, Cadmium Red Hue, Transparent Maroon, Mars Black and French Ultramarine. Mix each with a drop of fine detail drying medium.

Using a no. 4 filbert, glaze the hair with a mix of Indian Yellow Deep and a touch of Permanent Alizarin Crimson. The hair should look more golden. Add darks with Transparent Maroon and a no. 3 miniature. Add highlights with a Naples Yellow Light and Titanium White mixture. Blend lightly with a ½-inch (12mm) comb.

Use a gray scale to check the value of the whites of the eyes; adjust if needed with a blue-gray mix from step 6, adding a touch of Cadmium Red Scarlet Hue to gray the tone. Glaze the irises with Transparent Maroon. Reinforce the pupils and shadows of the eyes with a Transparent Maroon and French Ultramarine mixture. Reinforce the eyelashes with a no. 000 miniature and Transparent Maroon. Add Mars Black to the pupils.

Work subtle glazes into the cheeks and nose with Permanent Alizarin Crimson and a no. 2 short filbert. Blend with a no. 6 glazing brush. If the glaze is too abrupt, add a little Cadmium Red Scarlet Hue and Titanium White to the cheeks to integrate. For skin highlights, delicately scumble a mix of Titanium White and Naples Yellow Light with a no. 3 miniature. Soften with a no. 6 glazing brush.

Add a little Indian Yellow Deep subtly to the neck with a no. 2 short filbert. Work some Transparent Maroon into the shadow areas, including the nostrils.

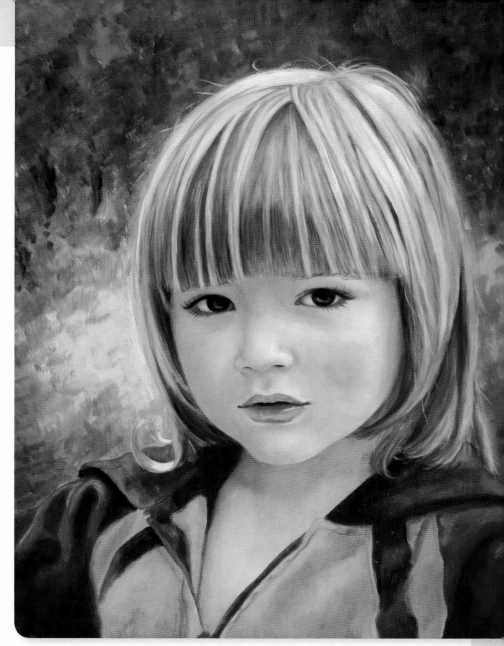

Bruno · oil on canvas · 12" × 9" (30cm × 23cm)

ARTIST'S TIP

Twirl your miniature brush for an extra-fine tip. Dip it in paint and gently twirl it on the palette until the line is fine. If necessary, add a tiny amount of solvent to the paint. Practice on your palette until you get a delicate line that is suitable for eyelashes and individual strands of hair. Use a no. 000 miniature if necessary. If your miniature just won't make a good point, buy a new one. Better that than ruining the painting with fake-looking eyelashes.

DEMONSTRATION 2
LIGHT SKIN AND STRAWBERRY BLOND HAIR

Capturing the expression of wonder on this toddler's face is the key to this painting. The down-swept lashes require delicate handling. The high forehead, the chubby cheeks and the small nose convey that this is a very young child. Notice the red reflected light on the complexion. Also be aware of the soft blues in some of the shadow areas.

Reference Photo

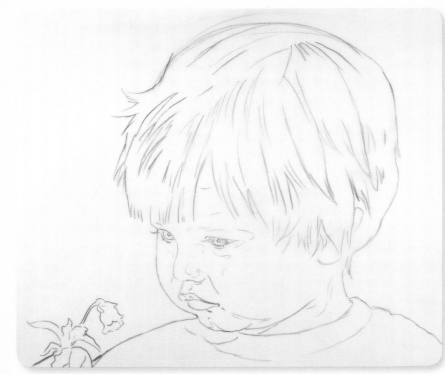

1 DRAW ON TRACING PAPER
Draw the toddler carefully on tracing paper. Pay special attention to the shape of the head and the eye level (see page 33). The younger the child, the lower the eye level. The slightly tilted head emphasizes this effect.

MATERIALS

Surface
9" × 12" (23cm × 30cm) gessoed canvas

Paints
Burnt Sienna (Alkyd), Burnt Umber, Cadmium Red Hue, Cadmium Red Scarlet Hue, Cadmium Yellow Hue, Indian Yellow Deep, Permanent Magenta, Titanium White, Transparent Maroon, Transparent Red Ochre, Winsor Blue (Green Shade)

Brushes
1-inch (25mm) and no. 6 flats
nos. 2, 4, 8, 14 filberts
no. 2 short filbert
nos. 0, 2 rounds
nos. 0, 4, 6 watercolor rounds
nos. 2, 3 miniatures
no. 6 glazing brush

Other Supplies
drying medium, fine detail drying medium, gray scale, palette knife, paper towels, pencil, red transfer paper, red watercolor pencil, solvent, tracing paper

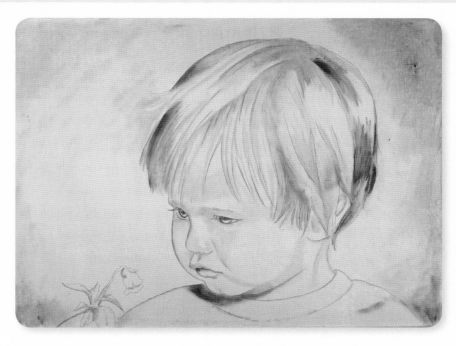

2 TONE THE CANVAS AND CREATE THE UNDERPAINTING

Using a 1-inch (25mm) flat, brush on a Burnt Sienna (Alkyd) wash, spreading it thinly. Smooth the face area with a paper towel. The tone should be a transparent reddish brown. Let it dry.

Carefully transfer the drawing with the transfer paper. Reinforce the drawing with a red watercolor pencil.

Use Burnt Umber for the underpainting. Use nos. 0 and 4 watercolor rounds to draw the image and nos. 2 and 4 filberts to scrub and blend it smooth as needed. Stroke the hair in the direction it flows. Add a tiny amount of solvent to the paint so that it's easy to manipulate. Let it dry.

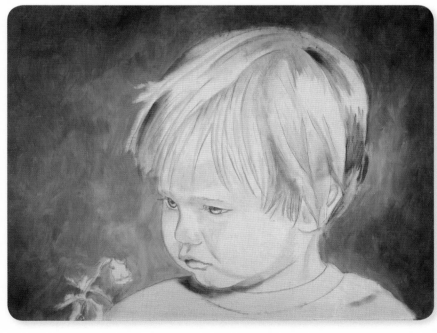

3 PAINT THE BACKGROUND

Lay out Titanium White, Cadmium Yellow Hue, Winsor Blue (Green Shade), Cadmium Red Hue and Permanent Magenta; stir a drop of drying medium into each color. Using more of the blue and yellow, paint a predominantly green background. Paint loosely, mixing partly on the canvas. Make the edges darker. Use a no. 14 filbert and don't clean your brush that often, letting the colors blend on the brush. Use a no. 0 round along the edges of the face. If the green looks garish, tone it down with Cadmium Red Hue.

ARTIST'S TIP

For a loose appearance in the background, avoid overmixing. Hold brushes at the end of the handle, working with your wrist rather than your fingers.

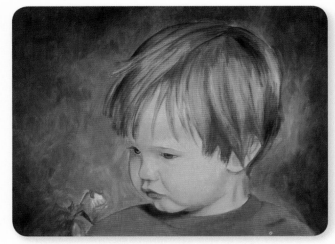
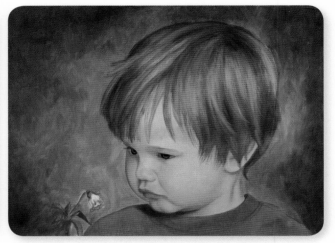

4 APPLY THE FIRST COAT TO ESTABLISH THE VALUES
Lay out Titanium White, Cadmium Red Scarlet Hue, Winsor Blue (Green Shade), Cadmium Yellow Hue and Permanent Magenta; stir a drop of drying medium into each color. Mix ten values from dark to light with the Titanium White, Cadmium Red Scarlet Hue and Winsor Blue. Winsor Blue is a powerful color, so use only a tiny amount. Mix seven more with Cadmium Yellow Hue, Permanent Magenta and Titanium White. Mix additional peach colors with Cadmium Yellow Hue, Cadmium Red Scarlet Hue and Titanium White for the rosy cheeks.

Use a gray scale to check values. Use a no. 2 short filbert to place the skin colors and a no. 6 glazing brush to blend. Use the darkest mix for the eyelashes and pupils. Use a Winsor Blue and Cadmium Yellow Hue mix for the irises and three values of a Winsor Blue and Titanium White mix for the whites. Use nos. 2 and 3 miniatures.

Mix Cadmium Red Scarlet Hue and Cadmium Yellow Hue for the lighter hair colors and Cadmium Red Scarlet Hue and Winsor Blue for the darks. Add small amounts of Titanium White to mix six values total. Apply them with a no. 4 watercolor round.

Use Cadmium Red Hue for the shirt. Mix some Winsor Blue and Permanent Magenta with the red for the shadow. Use a no. 4 filbert for broad areas and a no. 2 round for edges.

Mix a purple for the flower with Winsor Blue, Permanent Magenta and Titanium White. For a leaf green, mix Cadmium Yellow Hue and Winsor Blue. Apply the paint with miniatures.

5 APPLY A SECOND COAT TO DEVELOP THE COLORS
Mix sixteen different colors and values for the skin, half from Titanium White, Cadmium Scarlet Hue and Winsor Blue, and the other half from Titanium White, Cadmium Yellow Hue and Permanent Magenta. Mix three peach shades from Cadmium Yellow Hue, Titanium White and Cadmium Red Scarlet Hue. Restate the skin with a no. 2 short filbert, blending with a no. 6 glazing brush. Take note of subtle color changes. Make the cheeks rosy with the peach mixes. Use Cadmium Red Scarlet Hue on the lips, nose and crease on the neck. Use miniatures in tight areas.

Mix bluish white, greenish blue and a strong dark using Winsor Blue, Permanent Magenta and a little Cadmium Yellow Hue for the eyes. Use nos. 2 and 3 miniatures with a delicate touch. Keep the brush clean as you go back and forth between darks and lights.

Create six values for the hair using mostly Cadmium Red Scarlet Hue, Cadmium Yellow Hue and Permanent Magenta with little or no Titanium White. Use watercolor rounds and stroke in the direction the hair flows. Dark and light contrast makes hair shine, so record the value changes carefully. As you paint, the rounds will splay a little, giving the hair texture.

Using nos. 4 and 8 filberts, paint the shirt with Cadmium Red Scarlet Hue and Permanent Magenta.

Use miniatures to restate the flower with Permanent Magenta, Titanium White and a green made from Cadmium Yellow Hue and Winsor Blue.

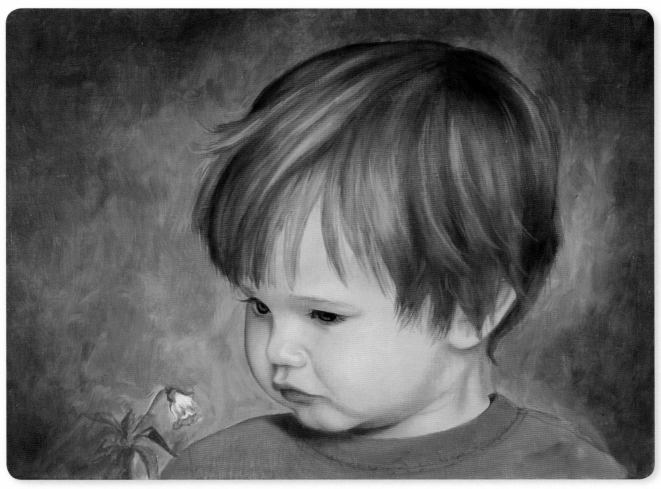

Ben · oil on canvas · 9" × 12" (23cm × 30cm)

6 ADD THE FINISHING TOUCHES

Use the same skin colors, emphasizing lighter tones. Using miniatures and a no. 2 short filbert, repaint the lightest areas of the face. This should both lighten and cool the skin. Use a no. 6 glazing brush to soften. Restate the darker skin shadows as needed with a no. 4 watercolor round. Use a no. 3 miniature to paint the reflected light under the chin and lips with Cadmium Red Scarlet Hue. Soften with a no. 6 glazing brush if needed.

Mix glazing colors by adding fine detail medium to Transparent Maroon, Indian Yellow Deep and Transparent Red Ochre. Use a no. 6 glazing brush to glaze the hair with Transparent Maroon in the dark areas, Transparent Red Ochre in the medium areas and Indian Yellow Deep in the light areas. Scumble a few highlights in the lightest areas with a mix of Titanium White, Cadmium Yellow Hue and Cadmium Red Scarlet Hue. Use a no. 4 watercolor round for the highlight. If the highlights look green, add more red to the white mixture. Use miniatures to add individual strands of hair with different values of golden red.

Add Cadmium Red Scarlet Hue and Titanium White to the inner lower eyelid.

Restate the eyelashes and pupils with Transparent Maroon and a touch of Winsor Blue. Use a no. 2 miniature and a light touch. Feather out the ends of the lashes with a touch of solvent if needed.

Use a no. 3 miniature to add stitching detail with a mix of Cadmium Red Scarlet Hue and Transparent Maroon.

Study the painting under different light or in a mirror to evaluate and decide what needs touching up.

BROWN SKIN AND BROWN HAIR

This is a great example of the way lighting can change brown skin from warm gold to subtle rose to deeper umber shades. The play of light and shadow across the face requires careful drawing. Observe and record all the subtle nuances of color and temperature. I used colors from both the dark and brown skin palettes.

Teeth are a challenge, but they're essential to this little girl's delightful smile. See page 27 for information on depicting teeth.

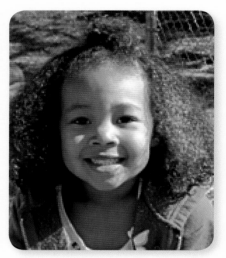

Reference Photo

MATERIALS

Surface
10" × 10" (25cm × 25cm) gessoed canvas

Paints
Bismuth Yellow, Burnt Sienna (Alkyd), Burnt Umber, Burnt Umber Warm, Cadmium Red Scarlet Hue, French Ultramarine, Green Gold, Indian Yellow (Alkyd), Indian Yellow Deep, Mars Black, Permanent Alizarin Crimson, Permanent Magenta, Titanium White, Venetian Red, Violet Deep

Brushes
nos. 2, 4, 6, 8, 14 filberts
no. 2 short filbert
no. 0 watercolor round
no. 6 glazing brush
homemade fan
nos. 2, 3 miniatures

Other Supplies
drying medium, fine detail drying medium, palette knife, paper towels, pencil, solvent, tracing paper

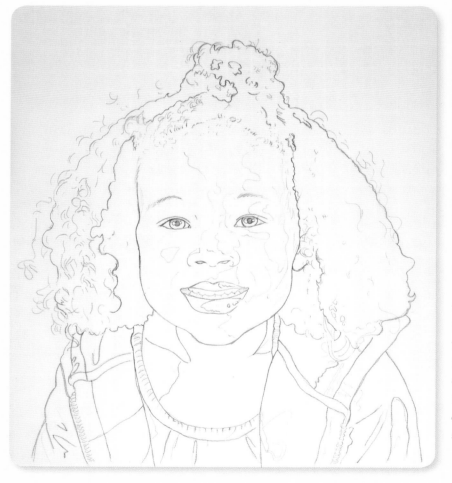

1 DRAW ON TRACING PAPER
Create a value map of the girl's face, paying attention to the teeth and smile. Don't try to draw every hair, just the general shapes and a few select strands. Notice that I changed the line of the blouse, bringing it higher than it is in the photo. A line that touches right on the edge of the canvas is a compositional distraction.

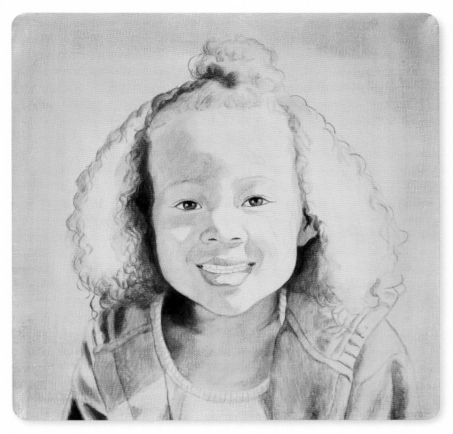

2 TONE THE CANVAS AND CREATE THE UNDERPAINTING

Mix Burnt Sienna (Alkyd) and Indian Yellow (Alkyd) for a warm, transparent amber. Brush on the wash with a no. 14 filbert and rub it smooth with a paper towel. Let it dry.

Transfer the drawing. The finest hair and zipper details can be omitted for now. Include the sunlit highlights on the face.

Lay out Burnt Umber Warm for a warm dark and Burnt Umber with a touch of Violet Deep for a cool dark. Use a no. 0 watercolor round to paint the details and use the filberts to paint the shadows. Don't paint too much detail in the teeth or they will look dingy. Create a basic value map. Keep it delicate. Remeasure and check your placement if necessary.

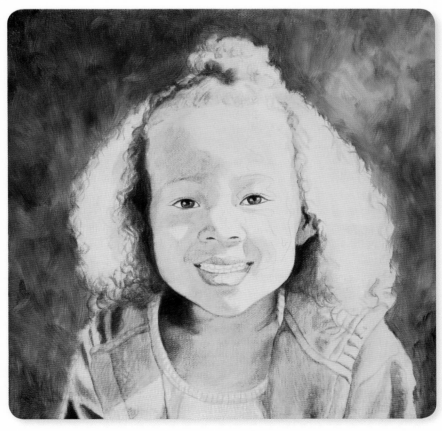

3 PAINT THE BACKGROUND

Add a drop of drying medium to the Green Gold, French Ultramarine, Bismuth Yellow, Venetian Red, Titanium White and Permanent Magenta. Use these colors to mix greens, golden greens and reddish browns. Make eight different values and hues. Use the larger filberts to place them on the background in a random fashion. Don't overmix or overblend.

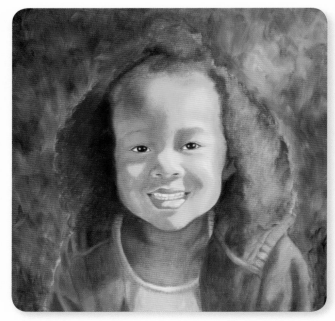

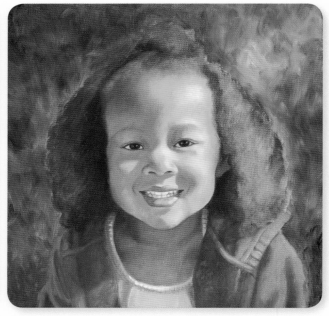

4 **APPLY THE FIRST COAT TO ESTABLISH THE VALUES**
Lay out Titanium White, Green Gold, Permanent Magenta, Venetian Red, French Ultramarine and Bismuth Yellow; stir a drop of drying medium into each color. Mix nine shades with Titanium White, Green Gold and Permanent Magenta and another nine with Titanium White, Venetian Red and French Ultramarine to create a range of light to dark and warm to cool.

Use a no. 2 short filbert to place the colors on the painting following your reference. Blend with a no. 6 glazing brush.

Don't worry about the details yet. Concentrate on the values and form. Use French Ultramarine and Titanium White for the whites of the eyes and teeth.

For the sweatshirt, mix varying values of French Ultramarine, Bismuth Yellow and Titanium White. For the blouse, mix Permanent Magenta, Titanium White and a touch of Green Gold. Paint the basic forms, saving details for later.

5 **APPLY A SECOND COAT TO DEVELOP THE COLORS**
Use the mixtures from step 4 plus Cadmium Red Scarlet Hue. Mix four values with Cadmium Red Scarlet Hue and Titanium White. Make an almost white warm light with Titanium White, Bismuth Yellow and Cadmium Red Scarlet Hue.

Restate the form, refining and developing it with a no. 2 short filbert. Study the reference. There are hints of blues, magentas and golds in the skin. You can work a little pure color in those areas. Use the warm light color for the sunlit highlights.

Rework the eyes, using a no. 2 miniature to paint and a no. 3 miniature to blend out harsh lines. Add the four red values to the lips, nostrils, inner corners and creases of the eyes.

Repaint the clothes as needed. Mix greens with Bismuth Yellow and French Ultramarine, and pinks with Permanent Magenta and Titanium White.

Deepen the shadows in the hair with a no. 8 filbert and a mix of French Ultramarine, Permanent Magenta and Venetian Red. Let it dry thoroughly.

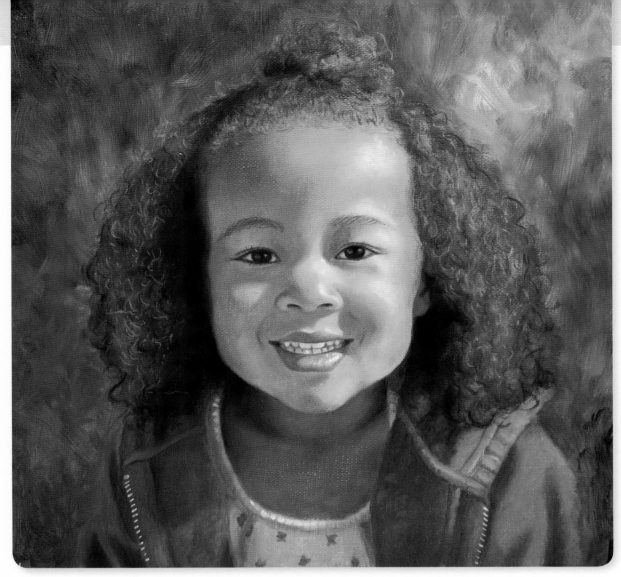

Jaidyn · oil on canvas · 10" × 10" (25cm × 25cm)

6 ADD THE FINISHING TOUCHES

Add fine detail drying medium to each color in this step. Mix a glaze of Permanent Alizarin Crimson and Indian Yellow Deep and another glaze of French Ultramarine and Permanent Magenta (use different proportions for four different glazes). Mix three varying highlighting colors with Titanium White, Indian Yellow Deep and Cadmium Red Scarlet Hue. Mix a couple of darks with Mars Black and Cadmium Red Scarlet Hue. Mix some background colors from step 3.

Glaze the skin with the glaze mixtures; apply warm colors in sunlit areas and cool colors in shadows. Use a stiff no. 14 filbert to spread the glaze very thinly. Work in highlights and restate areas as needed. Use the dark colors and a no. 2 miniature to stroke in the eyebrows and lashes. Soften with a no. 6 glazing brush. Deepen the darks in the eyes. Add glints with a light blue mix of Titanium White and French Ultramarine.

Glaze Permanent Alizarin Crimson on the lips and add light highlights with the highlight mix.

Use background colors and Cadmium Red Scarlet Hue in the clothes to integrate them into the background. Paint the zipper with the highlight mix. Paint the pattern on the blouse with Cadmium Red Scarlet Hue and a green mix of Indian Yellow Deep and French Ultramarine. Paint shadows on the sweater with a no. 8 filbert and a blue-green mix of Indian Yellow Deep and French Ultramarine.

For the hair, use varying dark and light mixes and layer in values with a no. 3 miniature and a homemade fan (see page 74). Blend and repeat until the hair has depth. Use a no. 2 miniature to bring some short strands down to meet the forehead. If the hair looks dull, let this coat dry, then add the warm glaze in sunlit areas and the cool glaze in shadows.

LIGHT SKIN AND ASH BLOND HAIR

The thoughtful gaze of this young boy is the focal point of the painting. Using blues, grays and greens in the background will bring out his eyes. His fair complexion is lightly tanned in areas, and his hair is bleached by the sun. Noting all the subtle color changes in his skin and hair will bring him to life.

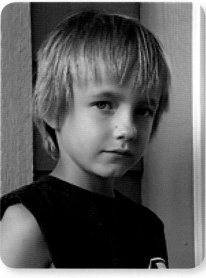

Reference Photo

MATERIALS

Surface
12" × 9" (30cm × 23cm) gessoed canvas

Paints
Burnt Sienna (Alkyd), Burnt Umber, Cadmium Red Scarlet Hue, Cadmium Yellow Hue, French Ultramarine, Green Gold, Indian Yellow Deep, Mars Black, Permanent Alizarin Crimson, Permanent Magenta, Titanium White, Winsor Violet Dioxazine

Brushes
no. 6 flat
nos. 00, 4, 6 filberts
no. 2 short filbert
nos. 0, 2 watercolor rounds
no. 6 glazing brush
¼-inch (6mm) comb
nos. 2, 3 miniatures

Other Supplies
drying medium, fine detail drying medium, palette knife, paper towels, pencil, red watercolor pencil, solvent, tracing paper

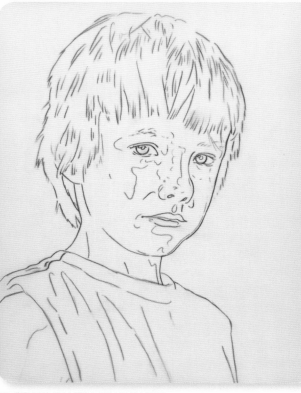

1 DRAW ON TRACING PAPER
Draw the boy on tracing paper. Make a map of the highlights and shadows on his face, hair and clothing.

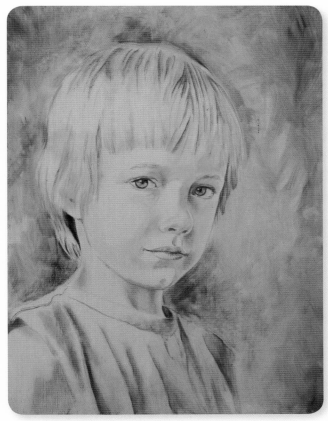

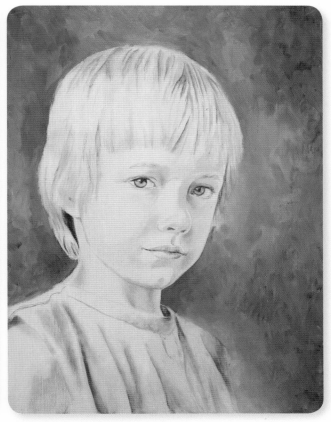

2 TONE THE CANVAS AND CREATE THE UNDERPAINTING

Brush on Burnt Sienna (Alkyd) with a no. 6 flat and smooth it out with a paper towel. Use solvent if necessary. Let it dry.

Transfer the drawing. Reinforce the drawing with a red watercolor pencil.

Draw the face with Burnt Umber and a no. 2 watercolor round. Use a no. 4 filbert to shade the face, scrubbing the paint into the canvas. Brush in background shadows.

3 ADD THE BACKGROUND

Add a drop of drying medium to each color: Titanium White, French Ultramarine, Cadmium Red Scarlet Hue, Permanent Magenta and Cadmium Yellow Hue. Loosely mix an assortment of grays, blues, blue-greens and purples. With your larger filberts, apply them to the canvas in a random manner. Use smaller rounds along the edges of the face. Use a palette knife to add texture. Keep it loose.

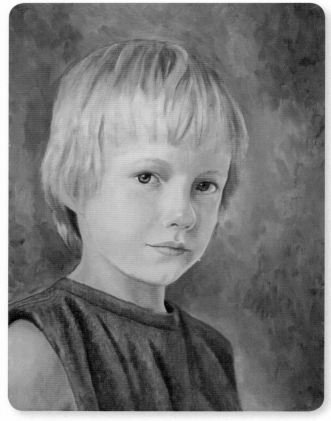

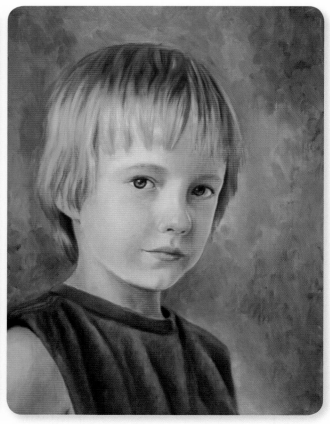

4 APPLY THE FIRST COAT TO ESTABLISH THE VALUES
Mix ten shades with Titanium White, French Ultramarine and Cadmium Red Scarlet Hue, ranging from dark to light and warm to cool. Do the same with Titanium White, Cadmium Yellow Hue and Permanent Magenta. Paint over the under-painting of the face, paying close attention to value. Do a small area at a time. Use smaller filberts and rounds, and blend with a no. 6 glazing brush. Use deep reddish hues for the creases in the eyelids, nose and lips.

Mix Titanium White and French Ultramarine in varying values for the whites of the eyes. Mix a bluish green from Cadmium Yellow Hue and French Ultramarine for the irises. Paint them thinly to look transparent. Use a mix of French Ultramarine and Permanent Magenta for the pupils and shadows from the upper eyelids.

Mix Cadmium Yellow Hue, Permanent Magenta, Cadmium Red Scarlet Hue, French Ultramarine and Titanium White to make six shades of blond hair, ranging from ash blond to dark brown. Paint the hair, paying attention to the shading; brush in the direction the hair falls. Paint the hair more warmly than you intend at this stage.

Mix four values out of French Ultramarine with a little Cadmium Red Scarlet Hue and Titanium White for the shirt.

5 APPLY A SECOND COAT TO DEVELOP THE COLORS
Use the same skin colors from step 4. Pay close attention to subtle color variations. In some areas the skin is more gold, in others more red or blue. Restate the skin, eyes and lips. Repaint only the areas that need work.

Mix nine values for the hair using combinations of Cadmium Yellow Hue, Titanium White, Permanent Magenta and Burnt Umber. Apply the colors, paying attention to form and value. Smooth with a no. 6 flat and a ¼-inch (6mm) comb. Add details with a no. 3 miniature and blend. Value contrast helps make hair shine.

Mix seven values for the shirt using Titanium White, French Ultramarine and a little Cadmium Red Scarlet Hue. Mix a bit more French Ultramarine into the darker shades. Brush the paint, smoothing slightly with a no. 2 short filbert. Try stippling (a dotting stroke) with a no. 4 filbert to create texture. Let it dry.

6 ADD THE FINISHING TOUCHES

Add fine detail drying medium to each color used in this step. For the hair, mix Green Gold and Permanent Magenta for a golden glaze, Indian Yellow Deep and Winsor Violet Dioxazine for a purplish brown glaze and Titanium White and Cadmium Yellow Hue for a highlight color. Brush the gold glaze over all the hair with a no. 4 filbert. Add dark shadows with the purplish brown glaze using a no. 0 watercolor round. Add highlights with a no. 2 watercolor round. Stroke in the hair with a no. 6 flat. Lighter colors tone down the brassiness of the hair.

Add touches of French Ultramarine and Green Gold to the irises with a miniature. Use Mars Black for the pupil and the shadow cast by the eyelid. Use a no. 2 miniature to indicate eyelashes with the brown glaze.

Glaze touches of Green Gold, Permanent Alizarin Crimson and Permanent Magenta separately to the skin. Add purplish brown glazes to the shadows. Glaze Permanent Alizarin Crimson on parts of the lips. Glaze a darker value of Permanent Magenta and Green Gold on the lip shadows with a no. 3 miniature.

Use a no. 2 watercolor round to add subtle details in the shadows around the nose, mouth and under the chin.

Mix French Ultramarine with a little Permanent Alizarin Crimson, and glaze over the shirt with a no. 6 filbert. Work a little French Ultramarine and Titanium White into the highlights with a no. 2 short filbert.

Glaze parts of the shoulder with a mix of Permanent Alizarin Crimson and Green Gold. If the skin needs more cool highlights, let the painting dry, then scumble a little Titanium White in the lighter areas with a no. 2 short filbert. This creates a pleasant, pearly effect on light skin.

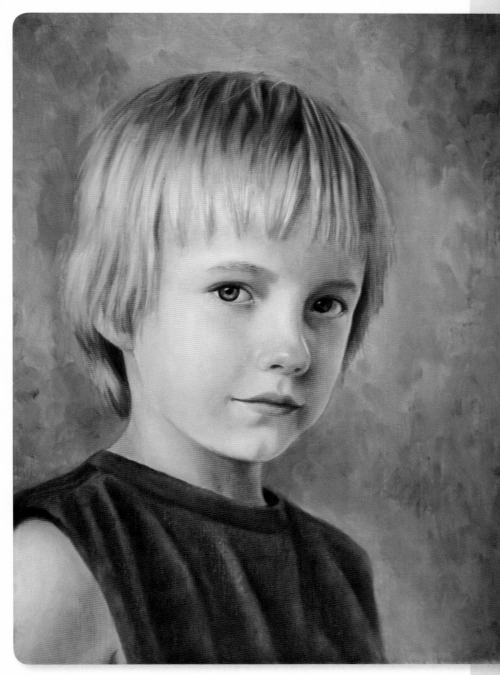

Luke · oil on canvas · 12" × 9" (30cm × 23cm)

LIGHT BROWN SKIN AND DARK HAIR

The inquisitive, intelligent expression in the girl's eyes is the focal point in this painting. The long, flowing, wind-blown hair with the backlighting will be challenging. Bear in mind the highlights on the hair will show up more if the background is medium toned rather than too light. Don't forget the ears; even though they are mostly hidden, they give the girl a pixieish personality.

Reference Photo
Photo by Jane Maday

MATERIALS

Surface
14" × 11" (36cm × 28cm) gessoed canvas

Paints
Bismuth Yellow, Burnt Sienna (Alkyd), Burnt Umber, Cadmium Red Scarlet Hue, French Ultramarine, Indian Yellow Deep, Mars Black, Permanent Alizarin Crimson, Permanent Magenta, Titanium White, Transparent Maroon, Violet Deep

Brushes
nos. 4, 12, 14 filberts
no. 2 short filbert
nos. 00, 0, 2 watercolor rounds
no. 6 glazing brush
nos. 2, 3 miniatures

Other Supplies
drying medium, fine detail drying medium, palette knife, paper towels, pencil, solvent, tracing paper

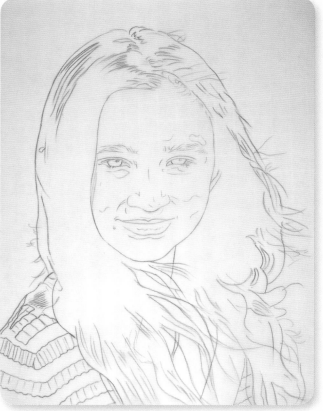

1 DRAW ON TRACING PAPER
Draw the girl on tracing paper with careful attention to the forms and shapes.

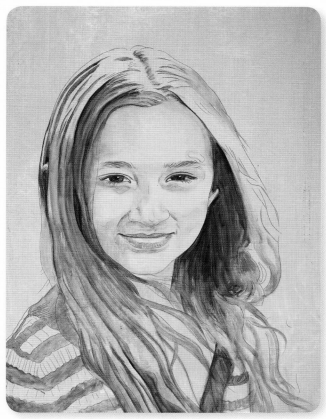

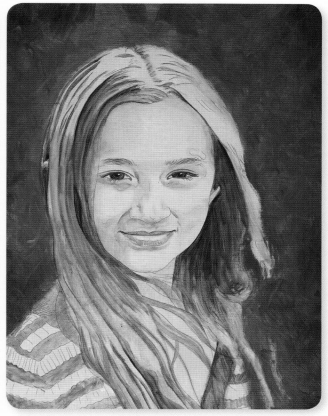

2 TONE THE CANVAS AND CREATE THE UNDERPAINTING

Apply a reddish brown glaze of Burnt Sienna (Alkyd) over the entire canvas with a no. 14 filbert. Rub it smooth with a paper towel. Let it dry.

Transfer the drawing. Then, mix a warmer dark and a cooler dark with Burnt Umber and Violet Deep. Use a no. 0 watercolor round and a no. 3 miniature to draw in the face. Use a no. 4 filbert to shade it. Use just a touch of solvent. Try to match your values and pay attention to accuracy.

3 ADD THE BACKGROUND

Mix a drop of drying medium into each color: Cadmium Red Scarlet Hue, French Ultramarine, Bismuth Yellow, Titanium White and Permanent Magenta. Using mostly the first four colors, mix a range of seven rusts, browns and olives.

Brush them on the canvas with a no. 12 filbert. Don't overblend or overmix. Keep it loose.

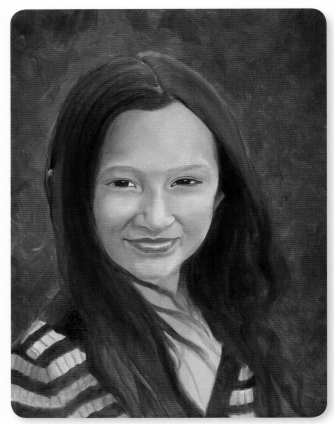

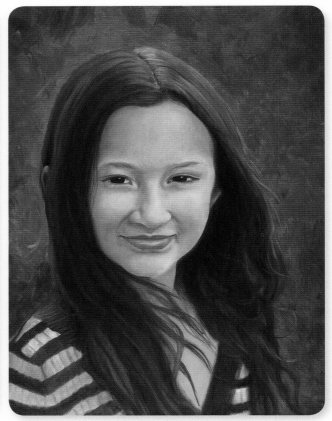

4 **APPLY THE FIRST COAT TO ESTABLISH THE VALUES**
Stir a drop of drying medium into each color: Titanium
White, Bismuth Yellow, Permanent Magenta, Cadmium Red
Scarlet Hue and French Ultramarine. Mix the first three colors
into eight variations: light, medium-light, medium-dark and
dark, some with more yellow, some with more red. Do the
same with Cadmium Red Scarlet Hue, French Ultramarine
and Titanium White. Apply with a no. 2 miniature, nos. 00 and
2 watercolor rounds, nos. 2 and 14 filberts, and a no. 6 glazing
brush. Develop the roundness of the form. Detail is not as
important at this stage. You want the basic forms, lights and
shadows.

Mix six values for the hair from Permanent Magenta,
French Ultramarine and Cadmium Red Scarlet Hue. Use
lighter skin tone colors for the highlights.

Mix Titanium White and French Ultramarine in several
values for the whites of the eyes and the sweater. Use a no.
4 filbert for the sweater and miniatures for the eyes. Use a
stronger dark blue for the darks in the sweater. Reserve your
lightest lights and darkest darks for the center of interest, the
eyes. Let this coat dry.

5 **APPLY A SECOND COAT TO DEVELOP THE COLORS**
Mix the same colors as in step 4. Using the same brushes,
rework the painting, matching color and value. Human skin
has irregularities. Using a dry brush, apply a little Cadmium
Red Scarlet Hue to the forehead, cheeks, nose and chin in a
delicate, random fashion. Blend with a no. 6 glazing brush.

Add more detail to the eyes and some indication of the
brows. Develop the dark shadows in the hair. You are still
working on form, light and shadow.

Evaluate your painting and think before you paint.

6 ADD THE FINISHING TOUCHES

Use the same colors as before. Add a drop of fine detail drying medium to each color. For glazes, mix Permanent Alizarin Crimson with Indian Yellow Deep, and Transparent Maroon with French Ultramarine. Mix highlights from Titanium White, Cadmium Red Scarlet Hue and Bismuth Yellow. Make darks from Cadmium Red Scarlet Hue and Mars Black. Mix several values and hues of each combination. Glaze the skin with the warm reddish glaze, spreading thinly. Work in skin tones and highlights with a no. 2 short filbert and a no. 4 filbert.

Thin the darks with solvent. Finely paint the eyebrows, eyes and eyelashes with miniatures, smoothing them with a no. 6 glazing brush. Apply different dark shades with a delicate touch. Use miniatures to add pale blue highlights for glints in the eyes. Glaze the lips with small watercolor rounds and Permanent Alizarin Crimson, then add highlights. Glaze darks into the hair, then work in highlights. Add a few pure Cadmium Red Scarlet Hue touches.

Use a no. 4 filbert to loosely remix some background colors and add them at the edges of the hair and clothes to integrate them into the painting. Soften the hairline, blending hair and skin tones along the edge with a no. 6 glazing brush and adding strands of hair with small watercolor rounds. Use a no. 4 filbert to glaze a warm, transparent mix of Indian Yellow Deep and Permanent Alizarin Crimson over the sweater to integrate it. If the hair or skin seems dull, let it dry, then reglaze it.

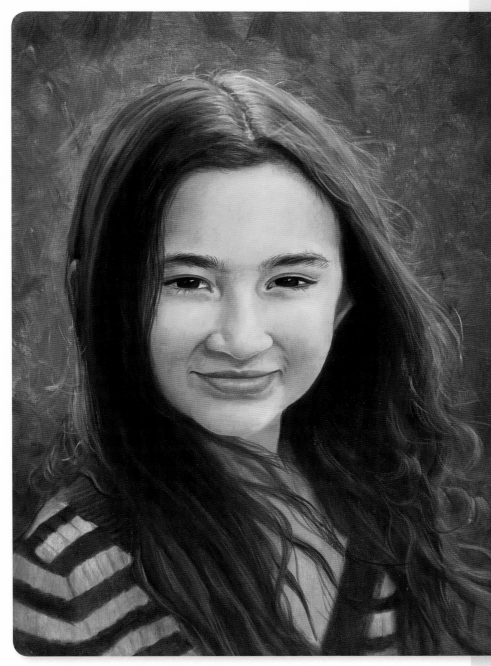

Emma · oil on canvas · 14" × 11" (36cm × 28cm)

TANNED SKIN AND LIGHT BROWN HAIR

Babies' soft, smooth faces can be challenging to paint. The blending brushes are very useful. The proportions of younger children and babies differ from older ones (see pages 21–29 for more on proportions).

I changed the color scheme from the photo, making the baby's outfit a warmer pink. The round brown eyes, full of wonder, are the center of interest. Place the darkest and lightest values there.

Reference Photo
Photo by Kay H. Perry

MATERIALS

Surface
12" × 9" (30cm × 23cm) gessoed canvas

Paints
Burnt Sienna (Alkyd), Burnt Umber, Cadmium Red Scarlet Hue, Cadmium Yellow Hue, French Ultramarine, Indian Yellow (Alkyd), Indian Yellow Deep, Mars Black, Permanent Alizarin Crimson, Terra Rosa, Titanium White, Transparent Maroon, Violet Deep, Yellow Ochre Pale

Brushes
1-inch (25mm) flat
nos. 00, 0, 2 watercolor rounds
nos. 2, 4, 8, 12 filberts
no. 2 short filbert
no. 4 round
nos. 6, 18 glazing brushes
nos. 0, 3 miniatures

Other Supplies
drying medium, fine detail drying medium, palette knife, paper towels, pencil, red watercolor pencil, solvent, tracing paper, transfer paper

1 DRAW ON TRACING PAPER
Carefully draw the baby, paying special attention to the proportions described on pages 24–29.

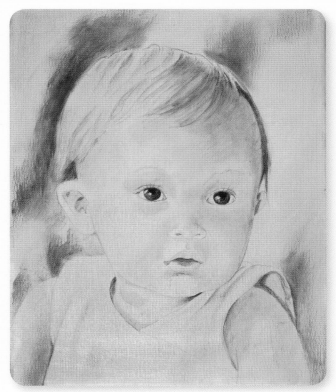

2 TONE THE CANVAS AND CREATE THE UNDERPAINTING
Create a warm reddish gold with Indian Yellow and Burnt Sienna. Brush on the mixture with a 1-inch (25mm) flat, and rub it in lightly with a paper towel, adding just enough solvent to the paint to make it spread. Let it dry.

Transfer the drawing. Reinforce the lines with a red watercolor pencil.

Mix Burnt Umber and Violet Deep for a warm dark and a cool dark. Use nos. 00 and 0 watercolor rounds and a no. 3 miniature for fine details, and a no. 4 filbert and no. 4 round for scrubbing in shading. Develop the form, paying attention to delicate nuances, such as the soft shading on the plump cheeks and high forehead. Take your time with the underpainting to capture the smooth softness.

3 PAINT THE BACKGROUND
Add a drop of drying medium to each color: Yellow Ochre Pale, Terra Rosa, French Ultramarine and Titanium White. Mix an assortment of grays and grayish pinks in eight values, four cool and four warm. Apply the mixtures loosely with larger filberts and rounds. Don't overblend or overmix.

4 APPLY THE FIRST COAT TO ESTABLISH THE VALUES
Add a drop of drying medium to each color: Titanium White, Indian Yellow Deep, Terra Rosa, Yellow Ochre Pale, Transparent Maroon and French Ultramarine. Create six mixtures with the first three colors, ranging from more yellow to more red, and lighter to darker. Do the same with Yellow Ochre Pale, Transparent Maroon and Titanium White. Mix French Ultramarine with Titanium White in three lighter values.

Studying your reference, paint the colors appropriately over the underpainting. Use a no. 2 short filbert and no. 4 filbert for the skin. Brush it smooth with glazing brushes. Use the same colors and a no. 4 round for the hair. Use a no. 3 miniature and the blue mixes for the whites of the eyes.

For the outfit, mix pink from Cadmium Red Scarlet Hue, Titanium White and a touch of French Ultramarine. Add the whites of the outfit with the lightest flesh tones. Omitting the stripes in the highlighted areas creates the illusion of sunlight. Let it dry.

5 APPLY A SECOND COAT TO DEVELOP THE COLORS
Mix the same colors as in step 4. Add Permanent Alizarin Crimson and mix it with Titanium White for varying pink values.

Repaint the face as in the previous step, further refining it and developing the form. Work on the eyes, nose and mouth. Use one brush to paint and another to blend. Use a no. 3 miniature to blend tight areas. The whites of the eyes are pale blue and have darker blue shadows. Deepen the eyes and shadows.

Repaint the hair and the outfit. Let it dry.

Because a baby's skin is so smooth, you may need to repeat this step. Evaluate your painting and decide if this is necessary.

6 ADD THE FINISHING TOUCHES

Add a drop of fine detail drying medium to the following colors: Indian Yellow Deep, Titanium White, Transparent Maroon, French Ultramarine, Cadmium Red Scarlet Hue, Cadmium Yellow Hue, Permanent Alizarin Crimson and Mars Black. Mix skin and hair glazes with Permanent Alizarin and Indian Yellow in varying proportions. Glaze this thinly over the skin and hair with a no. 4 round. Glaze the background randomly with a no. 4 filbert and French Ultramarine and a pinkish mix of Permanent Alizarin Crimson and Indian Yellow Deep, then blend in with a no. 18 glazing brush.

Mix a highlight color with Cadmium Yellow Hue and Titanium White, and paint highlights on the face. Use a no. 0 watercolor round to add highlights to the hair. Mix a strong dark with Cadmium Red Scarlet Hue and Mars Black to deepen the eyes. Add glints with a pale blue mix made from French Ultramarine and Titanium White. Mix dark, transparent colors with Transparent Maroon and French Ultramarine; thin the paint with solvent. Paint the delicate eyelashes with a no. 0 miniature.

Use a reddish mix of Cadmium Red Scarlet Hue and a touch of French Ultramarine for the eyebrows. Use the highlighting mix for individual light hairs and transparent colors for darker strands. If the hair is too cool, let it dry and glaze over it with a warm yellow. Study the face and go over it until you're satisfied.

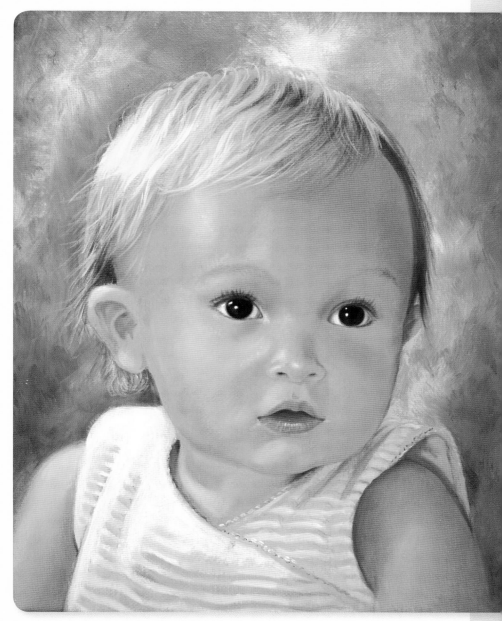

Brown Eyes · oil on canvas · 12" × 9" (30cm × 23cm)

DARK SKIN AND BLACK HAIR

The cropped hair sets off the exotic features of this young boy. I exaggerated the cool background to complement the warm honeys and browns of the skin and the amber-colored eyes. That will make the face come forward and stand out. In this case I made a few changes to the eyes because of the effects of the flash photography. I made both a black-and-white and a color copy to ensure value accuracy.

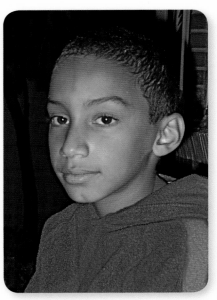

Reference Photo

MATERIALS

Surface
12" × 9" (30cm × 23cm) gessoed canvas

Paints
Burnt Sienna (Alkyd), Burnt Umber, Burnt Umber Cool, Cadmium Red Scarlet Hue, Cadmium Yellow Hue, Indian Red (Alkyd), Mars Black, Permanent Magenta, Titanium White, Transparent Maroon, Venetian Red, Violet Deep, Winsor Blue (Green Shade), Winsor Violet Dioxazine

Brushes
2-inch (51mm) flat
nos. 2, 4, 6, 8 filberts
nos. 2, 4 short filberts
nos. 0, 2, 3, 4 watercolor rounds
nos. 2, 3 miniatures
nos. 6, 18 glazing brushes

Other Supplies
drying medium, fine detail drying medium, gray scale, palette knife, paper towels, pencil, red watercolor pencil, solvent, tracing paper, transfer paper

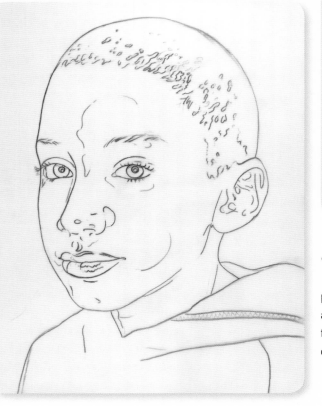

1 DRAW ON TRACING PAPER
Carefully draw the boy on tracing paper. Take special care with the ears and hairline. With short hair it is easier to see that the eye line is lower than it is on an adult.

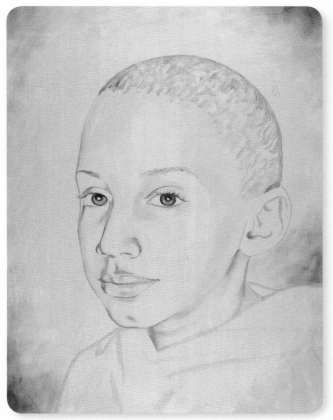

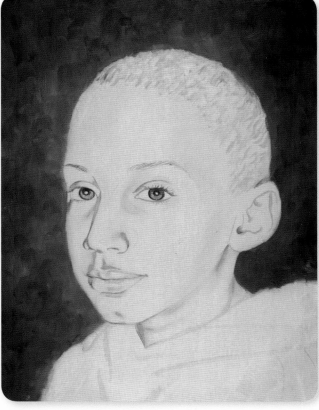

2 TONE THE CANVAS AND CREATE THE UNDERPAINTING

Mix Burnt Sienna, Indian Red and a touch of solvent, and brush it on the canvas with the 2-inch (51mm) flat. Smooth the face area with a paper towel. Let it dry.

Transfer the drawing and reinforce it with a red watercolor pencil. Use Burnt Umber for the face and Burnt Umber Cool for the hair. Paint in the features with nos. 2 and 4 watercolor rounds, and scrub in the shading with nos. 2 and 4 short filberts. Let it dry.

3 PAINT THE BACKGROUND

Add a drop of drying medium to each color: Titanium White, Cadmium Yellow Hue, Permanent Magenta, Venetian Red, Violet Deep and Winsor Blue. Loosely mix some blue-grays with Winsor Blue, Titanium White and Venetian Red, adding touches of the other colors. Do some of the mixing on the canvas. If you get background paint on the face, wipe it off with a paper towel. Keep it loose using larger nos. 6 and 8 filberts or even a palette knife.

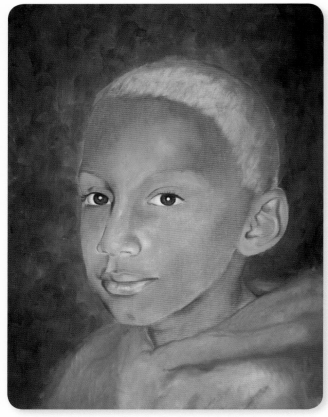 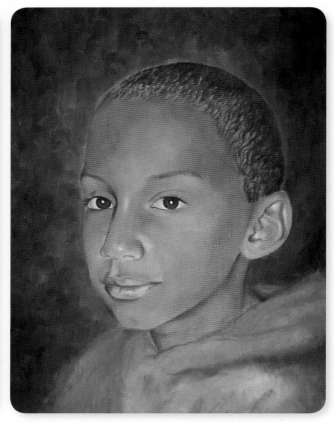

4 **APPLY THE FIRST COAT TO ESTABLISH THE VALUES**
Use the same colors as before, and add Cadmium Red
Scarlet Hue. Mix Cadmium Yellow Hue and Permanent Magenta,
then add progressively more Titanium White to create seven
values. Mix Winsor Blue and Venetian Red, adding progressively
more Titanium White to create five values. Repeat with Venetian
Red, Violet Deep and Titanium White.

Paint the values on the underpainting guided by a gray
scale. Paint the scalp a lighter grayer. Use nos. 2 and 4 filberts
and short filberts for broad areas, nos. 2 and 3 miniatures
and watercolor rounds for tight areas. Blend with a no. 6
glazing brush.

Mix three values of Winsor Blue and Titanium White for the
whites of the eyes. Use the darkest brown mixture for the pupils
and the lash lines. Use nos. 2 and 3 miniatures, cleaning
the brushes between light and dark colors. Paint the lips
with nos. 2 and 4 watercolor rounds; use a no. 2 miniature
for details. Use Cadmium Red Scarlet Hue in the creases.
Blend with a no. 6 glazing brush. Paint the ears with the same
brushes. Use the flesh colors, paying attention to value. Apply
Cadmium Red Scarlet Hue in the creases. Create four shades
of blue for the shirt with Titanium White, Winsor Blue and
touches of Venetian Red and Permanent Magenta. Apply
with a no. 4 filbert with a no. 2 round for details. Let it dry.

5 **APPLY A SECOND COAT TO DEVELOP THE COLORS**
Use the same colors from step 4. In addition, make some
peach values with Cadmium Red Scarlet Hue and Cadmium
Yellow Hue. Repaint the face with the same brushes as before,
adjusting values and subtle color differences. Use Cadmium
Red Scarlet Hue mixtures on the cheek and nose.

Use a no. 2 filbert to thinly paint the scalp with a gray mixture
of Winsor Blue and Venetian Red. Mix some dark browns for the
hair with Cadmium Red Scarlet Hue, Winsor Blue, Venetian
Red and Violet Deep. Use nos. 0, 2 and 4 watercolor rounds
on the hair, following the hair growth pattern. Let some of the
gray show through.

Using a no. 2 short filbert, stipple the shirt with Violet Deep
and a touch of Cadmium Yellow Hue. To stipple, hold the brush
perpendicular to the canvas and lightly tap the surface. Deepen
the shadows and add texture with stippling. Smooth a little with
a no. 6 glazing brush.

6 ADD THE FINISHING TOUCHES

Add a drop of fine detail drying medium to each color in this step. Mix Cadmium Yellow Hue and Permanent Magenta, then add progressively more Titanium White for five values. Do the same with Venetian Red and Violet Deep.

Use nos. 2 and 4 watercolor rounds and a mix of Transparent Maroon and Winsor Violet Dioxazine to darken the hair. As the rounds begin to splay, use them along the hairline and for the eyebrows. Use a no. 2 miniature for details on the eyebrows and hairline. Use the miniature to add a bit of lighter skin color along the hairline where the scalp shows. Soften the hair lightly with a no. 18 glazing brush.

Shade the face with nos. 2 and 4 watercolor rounds, using the darker skin mixes. For highlights, apply the lighter skin tones with a no. 2 filbert. Blend with a no. 6 glazing brush. Shade the planes of the face so it looks three-dimensional.

Use nos. 2 and 3 miniatures on the eyes. Darken the pupils with a Cadmium Red Scarlet Hue and Mars Black mix. Use the hair mix for the eyelashes. Deepen the iris color with Transparent Maroon. If the whites of the eyes look too startling, glaze a thin mix of Transparent Maroon and Cadmium Yellow Hue over them.

Use a no. 2 watercolor round to glaze the lips with a thin Cadmium Red Scarlet Hue and Permanent Magenta mix. Use a no. 2 miniature to apply Transparent Maroon on the shadows.

Mix several values of Winsor Blue, Violet Deep, Titanium White and a touch of Cadmium Red Scarlet Hue for the shirt. Stipple the shirt with the darkest mix, using a no. 4 short filbert. Stipple a light mix over that with a clean brush. Add shadows and stitching with a miniature. Blend lightly with a no. 6 glazing brush.

Repaint the background if needed, using a miniature along the edges.

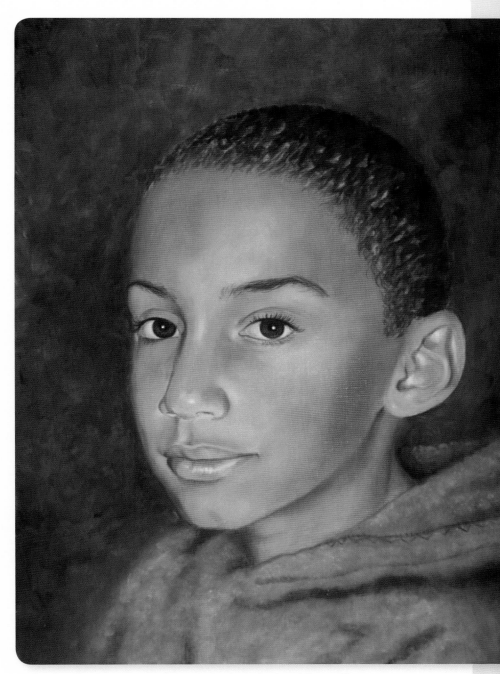

Mario · oil on canvas · 12" × 9" (30cm × 23cm) · collection of Carron Silva

OLIVE SKIN AND BLACK HAIR

Here we'll paint the lustrous black hair, delicate skin and dark, sparkling eyes of a young girl. Using Winsor Violet Dioxazine and Transparent Maroon in the shadows of the hair will give it depth. Subtle hints of Green Gold will help bring the olive skin tones to life. Use a glazing brush for colors and values that melt into each other.

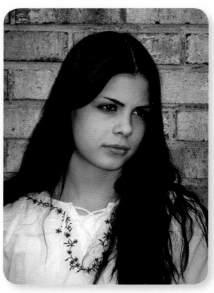

Reference Photo

MATERIALS

Surface
12" × 9" (30cm × 23cm) gessoed canvas

Paints
Burnt Sienna, Burnt Sienna (Alkyd), Burnt Umber, Cadmium Red Scarlet Hue, French Ultramarine, Green Gold, Indian Yellow (Alkyd), Mars Black, Permanent Alizarin Crimson, Rose Madder Genuine, Titanium White, Transparent Maroon, Winsor Violet Dioxazine, Yellow Ochre Pale

Brushes
nos. 4, 6, 14 filberts
no. 2 short filbert
nos. 0, 4 watercolor rounds
nos. 0, 4 rounds
no. 3 miniature
no. 4 fan
no. 6 glazing brush
½-inch (12mm) comb

Other supplies
drying medium, fine detail drying medium, gray scale, mahlstick, palette knife, paper towels, pencil, solvent, tracing paper, transfer paper

1 DRAW ON TRACING PAPER
Draw the girl on tracing paper. Outline the shapes of the colors and values. Include all the details in the eyes, hair and clothing.

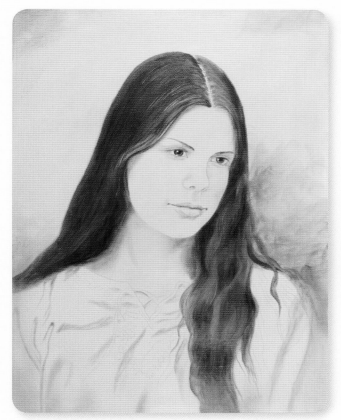 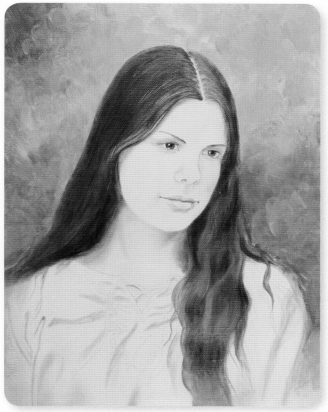

2 TONE THE CANVAS AND CREATE THE UNDERPAINTING
Mix Burnt Sienna (Alkyd) with a little Indian Yellow to warm it. Add just enough solvent to make it spreadable. Apply the mix to the canvas with a no. 14 filbert. Use a paper towel or a fan brush to soften it, creating a smooth, transparent, pale golden-brown tone. Let it dry.

Transfer the drawing. Omit the embroidery for now.

Mix Burnt Umber and Transparent Maroon for a rich warm dark. Mix Burnt Umber with Winsor Violet Dioxazine for a cooler dark. Add just enough solvent to each mix to make the paint spreadable. Using a no. 4 watercolor round, paint the face with the warm dark, and the hair and blouse with the cool dark. Stroke the brush in the direction that the hair flows. Use a ½-inch (12mm) comb to stroke the hair, stroking in the direction it flows.

Loosely brush in the background shadows with a no. 14 filbert. Take your time with the underpainting. Remeasure any areas that seem off. It's easier to repaint the underpainting than the painting.

3 PAINT THE BACKGROUND
Add a drop of drying medium to each color: Green Gold, Rose Madder Genuine, Titanium White, Cadmium Red Scarlet Hue, French Ultramarine and Burnt Sienna.

Mix three puddles of Green Gold and Rose Madder Genuine: one more green, one more red and one in between. Mix three puddles of Cadmium Red Scarlet Hue and French Ultramarine: one more red, one more blue and one in between.

Loosely brush in the background with nos. 6 and 14 filberts. Start with lighter colors, working to dark. Don't overmix. Add touches of pure Cadmium Red Scarlet Hue. Clean the brush with a paper towel occasionally. Drag a little color into the blouse at the edges. Let it dry.

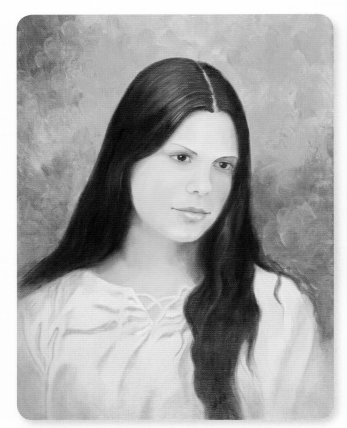

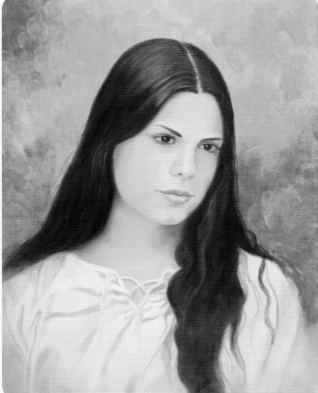

4 APPLY THE FIRST COAT TO ESTABLISH THE VALUES

Mix a drop of drying medium into each color in this step. Mix a range of sixteen skin and hair colors, ranging from nearly white to nearly black and from warm to cool. Create six mixtures with Titanium White, Green Gold and Permanent Alizarin Crimson, varying the value and hue. Create six mixtures of Cadmium Red Scarlet Hue, French Ultramarine and Titanium White. Create four mixtures of French Ultramarine, Transparent Maroon and Winsor Violet Dioxazine; add a touch of Titanium White to two of them.

Place colors next to each other in graduating values and hues to match the reference. Paint a small area at a time. Paint the face and neck with a no. 2 short filbert, focusing on the form. Use a dry no. 6 glazing brush to blend. Leave the brows until the next stage. Use a no. 3 miniature and a mix of French Ultramarine and Titanium White for the whites of the eyes.

Paint the hair the same way. Add highlights with a mix of Titanium White and Winsor Violet Dioxazine.

For the blouse, mix Titanium White with French Ultramarine, varying the values. Apply the paint with a no. 4 filbert and nos. 0 and 4 rounds. Use some flesh tones on the blouse. Add touches of pure unmixed color such as Cadmium Red Scarlet Hue in the left and right lower background. Let it dry.

5 APPLY A SECOND COAT TO DEVELOP THE COLORS

Use the same color mixtures and brushes from step 4. Check the values with a gray scale, and compare to your reference. Restate and correct values, and add more details in the eyes and hair. Model the form more tightly at the center of interest, the face and eyes. The edges of the painting may be left alone. Use miniatures for the eyes and brows. Use a mahlstick to steady your hand. Use a no. 6 glazing brush to blend. Let it dry.

6 ADD THE FINISHING TOUCHES
Transfer the embroidery design onto the canvas. Check the face against the drawing for errors.

Mix the same colors as in step 4, but use fine detail drying medium instead. Mix a reddish gold with Green Gold and Permanent Alizarin Crimson. Glaze this mixture on the face and neck with a no. 2 short filbert and no. 4 filbert, spreading the paint thinly. Model the flesh with the other skin tones as needed, working into the glaze. Reinforce the eyes, lashes and brows with a touch of Mars Black mixed with Cadmium Red Scarlet Hue. Use miniatures for the details.

Mix a warm, dark glaze with Transparent Maroon and French Ultramarine. Spread this thinly over the hair with a no. 6 filbert. Add highlights with Winsor Violet Dioxazine mixed with Titanium White using a ½-inch (12mm) comb and a no. 3 miniature.

For the embroidery, mix French Ultramarine with Titanium White and a touch of Cadmium Red Scarlet Hue. Mix French Ultramarine with Yellow Ochre Pale to make a soft green. Use a no. 3 miniature to make delicate hatch marks to imitate embroidery stitches.

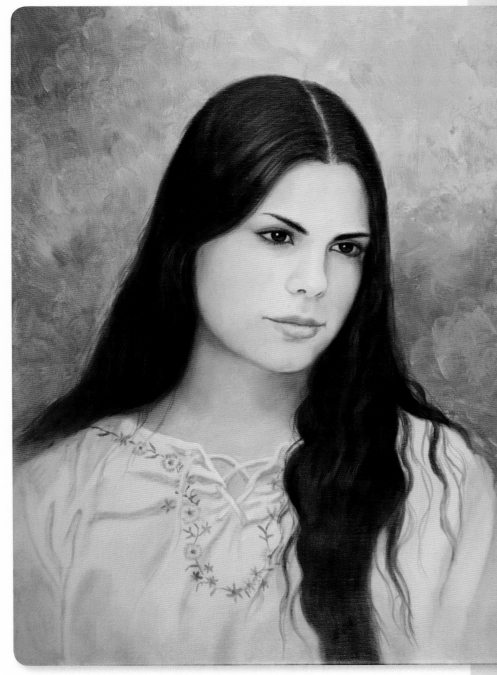

Kaitlyn · oil on canvas · 12" × 9" (30cm × 23cm) · collection of Frank and Carol Lisi

LIGHT SKIN AND DARK BROWN HAIR

The hat adds an interesting compositional element to this young girl's portrait. Notice the way the hat affects the lighting. To get the details in the shadows on the hair I printed two photos: one with normal settings and one that I enhanced on my computer to emphasize the details in the shadows.

The girl's sparkling eyes are the focal point.

Reference Photo
Photo by Jane Maday

MATERIALS

Surface
14" × 11" (36cm × 28cm) gessoed canvas

Paints
Burnt Umber, Cadmium Red Scarlet Hue, Cadmium Yellow Hue, French Ultramarine, Indian Red (Alkyd), Mars Black, Permanent Alizarin Crimson, Permanent Magenta, Titanium White, Transparent Maroon, Yellow Ochre Pale

Brushes
1-inch (25mm) flat
nos. 1, 2, 3, 4, 8, 14 filberts
nos. 2, 4 short filberts
nos. 00, 0, 1, 2, 4 watercolor rounds
nos. 2, 3 miniatures
no. 6 glazing brush

Other Supplies
drying medium, fine detail drying medium, palette knife, paper towels, pencil, red transfer paper, red water-color pencil, solvent, tracing paper

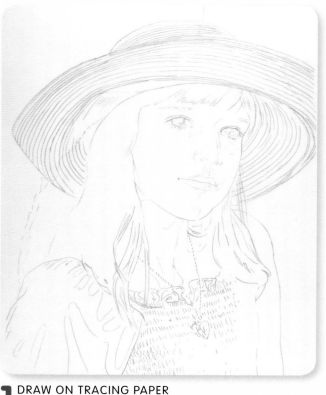

1 DRAW ON TRACING PAPER
Draw the girl carefully on tracing paper. Note the changes in lighting caused by the shadows from the hat.

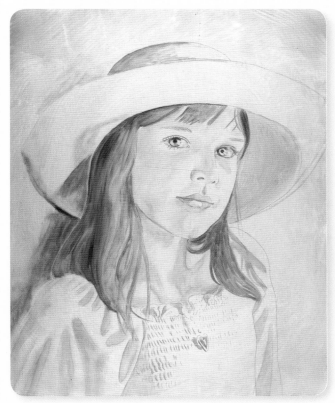

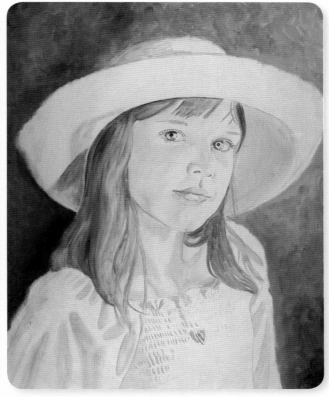

2 **TONE THE CANVAS AND CREATE THE UNDERPAINTING**
Paint on the Indian Red with a 1-inch (25mm) flat. Smooth the face and blouse areas with a paper towel. Let it dry.

Transfer the drawing and reinforce where necessary with a red watercolor pencil. Omit the details on the hat and necklace for now.

Mix Burnt Umber with a touch of solvent. Too much will make it streaky. Paint the face using nos. 00, 0 and 2 water-color rounds. Use nos. 1, 2 and 4 filberts to shade the painting, scrubbing the paint in and smoothing it to create a sepia-like portrait.

3 **PAINT THE BACKGROUND**
Add a drop of drying medium to Titanium White, Cadmium Yellow Hue, Yellow Ochre Pale, Permanent Alizarin Crimson, Permanent Magenta and French Ultramarine. Use these colors to mix pinks, oranges, peaches and browns. Paint on the canvas with nos. 8 and 14 filberts, mixing some of the colors directly on the canvas. Keep it loose and don't overblend.

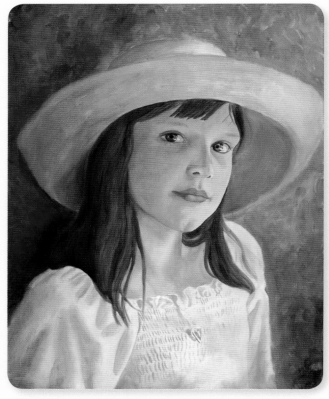
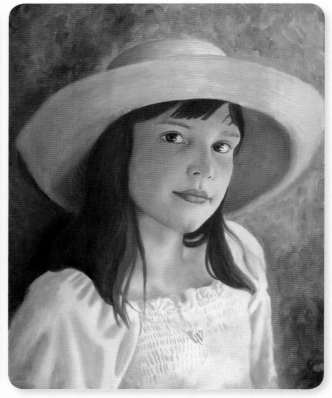

4 APPLY THE FIRST COAT TO ESTABLISH THE VALUES

Add a drop of drying medium to each color used in this step. Mix nine values of Titanium White, Yellow Ochre Pale and Permanent Alizarin Crimson, and four values of Titanium White, Permanent Magenta and Cadmium Yellow Hue.

Apply the skin values with nos. 1, 2 and 4 filberts, matching the value to the reference. Note that the hat shades the skin, making it darker. Once you've established accurate values, use a no. 6 glazing brush to smooth the skin.

Mix a dark brownish purple with Permanent Magenta, French Ultramarine and Cadmium Yellow Hue. Use this for the darks of the eyes. For the lights, use Titanium White and French Ultramarine in varying values. Use nos. 2 and 3 miniatures for the eyes.

Use nos. 2 and 4 filberts and light skin tones and Titanium White for the dress. Mix a little background color at the edges.

Mix more Yellow Ochre Pale and Cadmium Yellow Hue into the skin tone mixtures for the hat. Use the dark mix for the shadows. Use the same brushes as for the dress.

Use the dark mix for the hair, stroking in the direction it flows. Use a no. 4 filbert and a no. 4 watercolor round for the hair and bangs.

5 APPLY A SECOND COAT TO DEVELOP THE COLORS

In addition to the color mixes from step 4, mix three peach tones of differing values with Titanium White, Cadmium Yellow Hue and Permanent Alizarin Crimson. Use nos. 1, 3 and 4 filberts to restate the skin. Use a glazing brush to blend.

Repaint the eyes with nos. 2 and 3 miniatures, keeping the brushes clean as you go from darks to lights. Study and follow the shapes for the white glints. Use a strong purplish brown made from Permanent Alizarin Crimson, French Ultramarine and a touch of Cadmium Yellow Hue for the pupils and base of the lashes. Repaint the irises with a mix of Cadmium Yellow Hue and French Ultramarine. Paint the whites with Titanium White, French Ultramarine and a bit of Cadmium Red Scarlet Hue.

Use a no. 4 filbert and a no. 1 watercolor round to restate the shape of the hat with four gold values mixed from Yellow Ochre Pale, Cadmium Yellow Hue and Permanent Magenta. Use some Titanium White in the highlighted areas.

Use the same brushes for the blouse. Use lighter values of skin tones. Refine the areas closer to the neck. Use miniatures for the pleating.

Use a no. 4 watercolor round and the same dark for the pupils. Stroke in the hair. Add light streaks of gold. Let it dry.

Place the tracing over the painting. Transfer the details on the hat and the necklace onto the painting with red transfer paper.

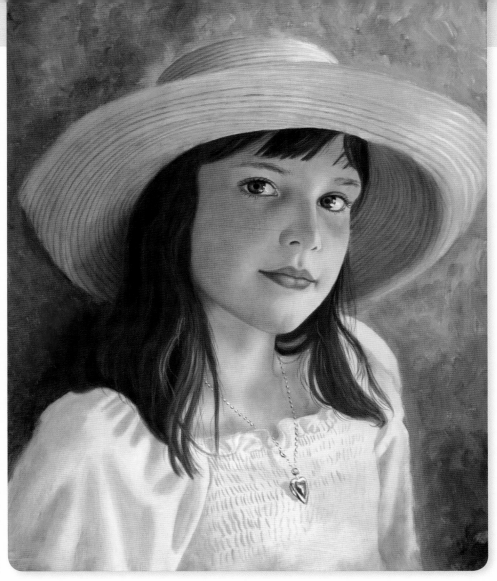

Margaret · oil on canvas · 14" × 11" (36cm × 28cm) · collection of Jane Maday

6 ADD THE FINISHING TOUCHES

Mix a drop of fine detail drying medium into each color in this step. Restate the face as needed, using a no. 2 short filbert. Add rosy cheeks. Paint freckles with a no. 3 miniature and a darker flesh tone. Use the miniature to add subtle shadows (glazes) and highlights (scumbles) with dark and light values. Blend with a no. 6 glazing brush.

Use a no. 2 miniature to paint the eyes. Mix French Ultramarine and Titanium White in three values. Use pure Titanium White for the glints and Mars Black for the pupil. Paint the base of the eyelashes with a mix of Cadmium Red Scarlet Hue and Mars Black. Add Cadmium Red Scarlet Hue along the creases around the eyelid. Paint eyelashes with Transparent Maroon. Use a delicate touch and blend lightly.

Restate the lips with a mix of Cadmium Red Scarlet Hue and Permanent Alizarin Crimson. Use Transparent Maroon in the shadows of the lips. Add highlights with Titanium White

and a touch of Cadmium Red Scarlet Hue. Use a no. 3 miniature and a no. 6 glazing brush.

Use Transparent Maroon and a no. 3 miniature to paint the details on the straw hat, following the curve of the transferred red lines. Add a few highlights with a Titanium White and Cadmium Yellow Hue mix.

For the hair, apply Transparent Maroon plain and mixed with a little Permanent Magenta with a no. 4 watercolor round. Use Mars Black with Cadmium Red Scarlet Hue for the shadows. Apply Cadmium Yellow Hue and Cadmium Red Scarlet Hue with a touch of Titanium White for the lighter strands. Add individual strands with a no. 3 miniature.

Mix French Ultramarine with a little Cadmium Red Scarlet Hue and Titanium White. Use a no. 2 miniature to brush on the darker parts of the necklace. Paint pure Titanium White highlights on the necklace. The contrast will make it sparkle.

MEDIUM SKIN AND DARK BROWN HAIR

This photo of a young boy holding a flower is an opportunity to paint the sheen on dark hair. The down-swept lashes of a lowered gaze will need a delicate touch and a tiny brush. Review the section on page 34 before tackling the hands. There are special tips that will help with this challenging subject.

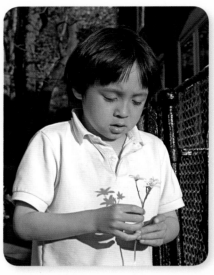

Reference Photo
Photo by Kay H. Perry

MATERIALS

Surface
14" × 11" (36cm × 28cm) gessoed canvas

Paint
Burnt Sienna (Alkyd), Burnt Umber, Cadmium Red Scarlet Hue, Cadmium Yellow Hue, French Ultramarine, Indian Yellow (Alkyd), Indian Yellow Deep, Mars Black, Permanent Alizarin Crimson, Titanium White, Transparent Maroon, Violet Deep, Winsor Blue (Green Shade), Yellow Ochre Pale

Brushes
no. 6 flat
nos. 2, 4, 6, 14 filberts
nos. 0, 2, 4 watercolor rounds
nos. 0, 2 miniatures
no. 6 glazing brush

Other Supplies
drying medium, fine detail drying medium, gray scale, paper towels, pencil, solvent, tracing paper, transfer paper

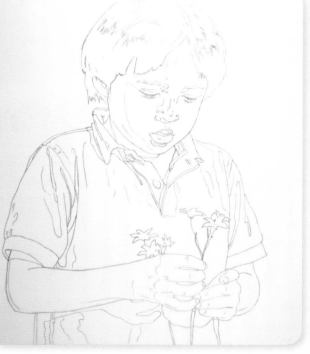

1 DRAW ON TRACING PAPER
Outline the values, shapes and colors of the boy carefully. Focus on recording the proportions accurately.

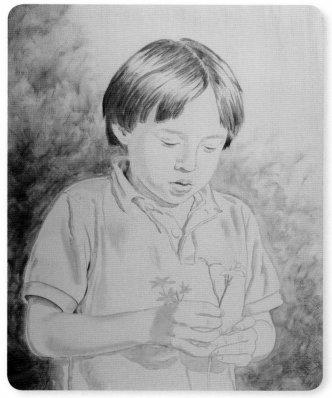

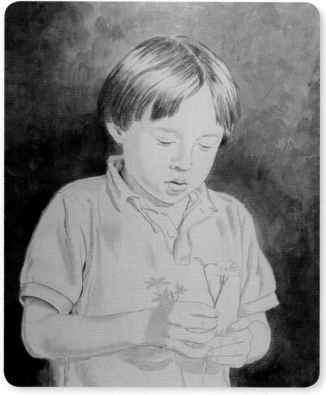

2 TONE THE CANVAS AND CREATE THE UNDERPAINTING
Mix Indian Yellow and Burnt Sienna to create a warm amber. Brush the paint on the canvas with a no. 14 filbert and rub it smooth with a paper towel. Use just enough solvent to make the paint spreadable. Let it dry.

Transfer the drawing. Lay out Burnt Umber and a mixture of Burnt Umber and Violet Deep on your palette. Add a touch of solvent.

Use finer brushes like pencils to draw the figure. Use larger brushes to scrub in shading. Take your time with the underpainting. Model the form, creating a full range of values.

3 PAINT THE BACKGROUND
Mix a drop of drying medium into each color in this step. Create three shades with Cadmium Yellow Hue, Titanium White and Violet Deep, ranging from light to dark. Mix another three values with Titanium White, Cadmium Yellow Hue and Winsor Blue. Add a touch of Burnt Sienna to neutralize the green. Don't overmix.

Apply the lighter colors in the upper canvas and darker colors in the lower canvas with a no. 14 filbert. Use a no. 2 watercolor round along the edges of the figure. Go back and forth between the colors and values. Don't blend. Clean the brush occasionally with a paper towel. Vary the direction of your strokes.

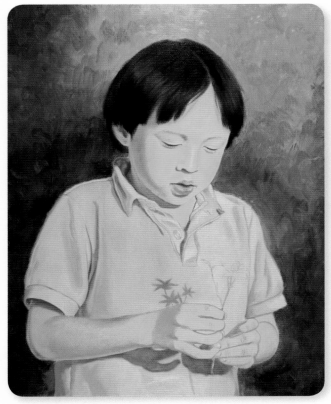
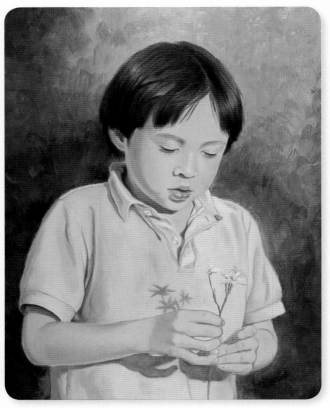

4 APPLY THE FIRST COAT TO ESTABLISH THE VALUES

Mix a drop of drying medium into each color in this step. Create twenty different values and hues. Mix warm and cool skin colors ranging from light to dark with Titanium White, Cadmium Yellow Hue and Permanent Alizarin Crimson. Mix another range of flesh tones from Yellow Ochre Pale, Transparent Maroon and Titanium White. Mix warm and cool darks from Transparent Maroon, Burnt Umber, Winsor Blue, Violet Deep and Cadmium Red Scarlet Hue.

Use nos. 0, 2 and 4 filberts and watercolor rounds to place the colors following the reference. Use a no. 6 glazing brush as needed. Paint the face and arms. Use the darker values for the hair. At this stage, form is more important than detail. Use a gray scale.

Create six shades for the shirt. Mix three values (light, light-medium and medium) in warm and cool variations with Titanium White, Yellow Ochre Pale, Transparent Maroon and a touch of Winsor Blue. Apply the paint appropriately using the gray scale and a no. 6 filbert and no. 4 watercolor round.

5 APPLY A SECOND COAT TO DEVELOP THE COLORS

Use the same colors and brushes from step 4. Use a gray scale to establish the values and restate the form, paying attention to subtle color variations. Use the miniatures for eyelashes, brows and other details. Use a light touch and blend with a no. 6 glazing brush. Use mixes with Cadmium Red Scarlet Hue for shadows and creases on the face and hands.

For the hair highlights, use a mix of Cadmium Scarlet and Titanium White. Add dark shadows with miniatures and a mixture of Cadmium Red Scarlet Hue and Winsor Blue.

Use the same shirt colors as in step 4. Add highlights and shadows and repaint as needed.

Paint the flowers with miniatures and three graduating mixes of Titanium White and Winsor Blue (light to dark). The cooler colors will stand out against the shirt. Mix Winsor Blue, Yellow Ochre Pale and Permanent Alizarin Crimson for the stem. Vary the mix for different parts of the stem so it looks more natural. Don't make it too bright a green.

ARTIST'S TIP

Don't mix too many colors together. Two or three should suffice. This will prevent the colors from getting muddy. You can put different color mixes side by side on the painting and blend them on the canvas.

6 ADD THE FINISHING TOUCHES
Mix a drop of fine detail drying medium to each color in this step. Add Mars Black and Indian Yellow Deep to your palette from the previous steps. Mix an assortment of skin values as in step 4.

Mix a golden skin glaze of Indian Yellow Deep and Permanent Alizarin Crimson (no white). Glaze this over the skin with a no. 4 watercolor round, brushing it out so it warms the tone. Work the opaque skin values into the flesh as needed. Add highlights and shadows. Refine the eyebrows, lashes, lips and other details with nos. 0 and 2 miniatures. Use Cadmium Red Scarlet Hue mixes for creases, inside nostrils and around fingers.

Paint Titanium White over the flower petals. Add green details to the stem with a Yellow Ochre Pale and French Ultramarine mix and a no. 2 miniature.

Mix a hair glaze with Indian Yellow Deep and Transparent Maroon. Brush this over the hair with a no. 4 filbert. Add highlights with Cadmium Red Scarlet Hue and Titanium White.

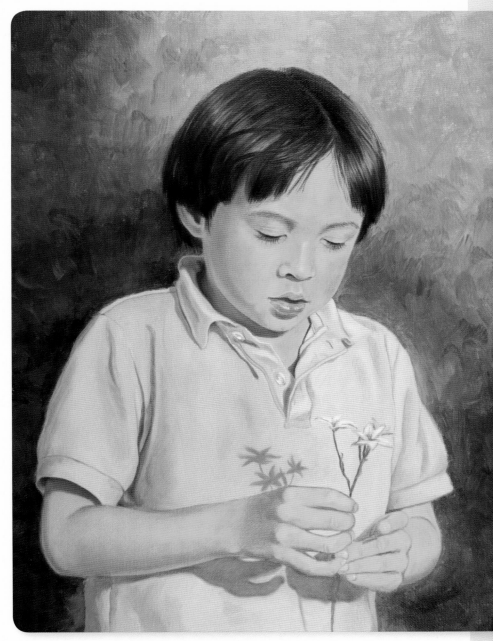

James · oil on canvas · 14" x 11" (36cm x 28cm)

DEMONSTRATION 11
LIGHT SKIN AND FLAX BLOND HAIR

The tough guy expression on this little cowboy's face is a challenge. I worked from a black-and-white photo, extrapolating the colors. Some artists find it easier to work from black and white because the values are more obvious. Try this approach if you struggle with values.

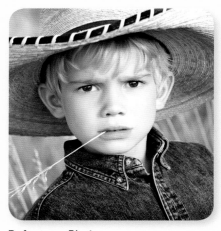

Reference Photo
Photo by photographybydesiree.com

MATERIALS

Surface
12" × 9" (30cm × 23cm) gessoed canvas

paint
Burnt Sienna (Alkyd), Burnt Umber, Cadmium Red Hue, Cadmium Yellow Hue, French Ultramarine, Indian Yellow Deep, Mars Black, Naples Yellow Light, Permanent Alizarin Crimson, Titanium White, Venetian Red

brushes
1-inch (25mm) flat
no. 4 filbert
no. 2 short filbert
no. 4 watercolor round
nos. 3, 4 miniatures
no. 6 glazing brush
½-inch (12mm) comb

other supplies
drying medium, fine detail drying medium, gray scale, palette knife, paper towels, pencil, red transfer paper, red watercolor pencil, solvent, tracing paper

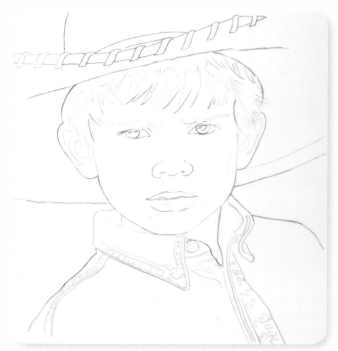

1 DRAW ON TRACING PAPER
Draw the boy on tracing paper, paying attention to the shapes of his eyebrows and mouth. His eyes have a slight squint. There are subtle shadows on his forehead. Record all the shapes of the shadows on the face and hair, including those cast by the hat.

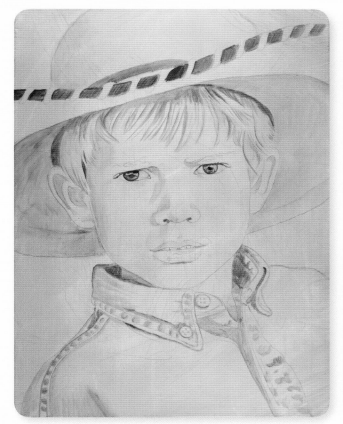

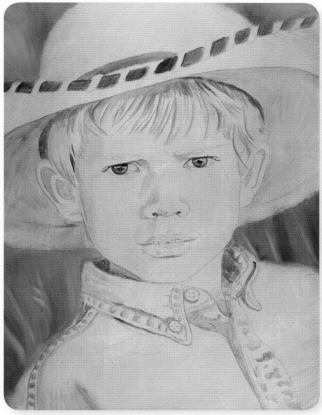

2 **TONE THE CANVAS AND CREATE THE UNDERPAINTING**
Use a 1-inch (25mm) flat to brush Burnt Sienna on the canvas. Smooth the face area with a paper towel. Let it dry.

Transfer the drawing, making sure it's properly centered. Reinforce lines with a red watercolor pencil.

Mix Burnt Umber with a touch of solvent and apply with a no. 3 miniature and a no. 4 watercolor round. Use a no. 2 short filbert for shading, scrubbing into the canvas. Get the values as close as you can using only the one color.

3 **PAINT THE BACKGROUND**
Mix a drop of drying medium into each color: Titanium White, Naples Yellow Light , Venetian Red, Cadmium Red Hue, French Ultramarine and Cadmium Yellow Hue. Mix a few grays from French Ultramarine and Cadmium Red Hue. Mix several shades of tans from Naples Yellow Light and Venetian Red. Using a no. 4 filbert, apply the paint, stroking in the direction of the flow of the wheat. Mix in a bit of Cadmium Yellow Hue and add touches of pure Naples Yellow Light. Blend with a no. 6 glazing brush.

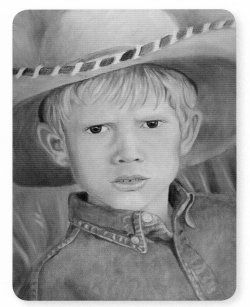

4 APPLY THE FIRST COAT TO ESTABLISH THE VALUES

Mix twenty skin tones with Titanium White, Naples Yellow Light, Venetian Red, Cadmium Red Hue and French Ultramarine. Use a no. 2 short filbert. Paint the dark values, then medium and light. Blend with a no. 6 glazing brush.

Use a miniature on the eyes. Mix light blue-grays with Titanium White and French Ultramarine for the whites. Use a dark mix of French Ultramarine and Cadmium Red Hue for the pupils and shading on the irises. Paint the irises a bluer blue-gray. Paint creases on the eyelids with a reddish brown mix of Cadmium Red Hue and French Ultramarine.

Use a miniature and a skin mix with more Cadmium Red Hue for the lips. Paint the teeth a blue-gray and the dark of the mouth with a dark red.

Use a no. 4 watercolor round and a dark red skin mix for the ears and neck. Put in the shadows, then the mediums and lights. Blend.

Paint the hair with browner skin values and Naples Yellow Light. Add Cadmium Yellow Hue. Use a no. 4 filbert and a no. 3 miniature. Use a ½-inch (12mm) comb to stroke in the direction of the flow.

Use the same colors for the hat, adding a little Cadmium Red Hue. Use a no. 4 filbert and a no. 4 watercolor round, then blend with a no. 6 glazing brush.

For the shirt, make two blue mixes with French Ultramarine, Cadmium Red Hue and Titanium White. Paint the medium blue thinly, scrubbing with a no. 4 filbert so the grain shows. Paint the dark blue into the shadows with a no. 3 miniature. Use solvent on a clean miniature to lift the paint off the areas where the denim is faded. Blend lightly and let it dry.

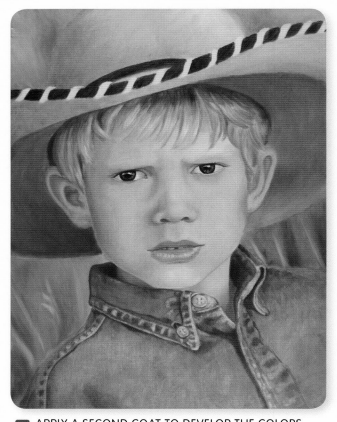

5 APPLY A SECOND COAT TO DEVELOP THE COLORS

Restate the skin using the same brushes and colors from step 4. Establish deeper values and richer color. Refine the eyes and nose. Indicate the curve of the eyeball and the shadow cast by the eyelid with delicate shading. Add color to the lips. Use the gray scale to check the value on the teeth and the gap between the teeth. The gap is a reddish mix of Cadmium Red Hue and French Ultramarine. The teeth are a mix of French Ultramarine, Titanium White and a touch of Cadmium Red Hue. The teeth curve away and become darker at the corners of the mouth.

Restate the hair, placing the values as accurately as you can. Do the same with the hat, which is slightly redder than the hair. Add the lights on the rim with a mix of Titanium White and Naples Yellow Light. Paint the darks with a mix of Cadmium Red Hue and French Ultramarine.

Add some shading to the denim with a mix of French Ultramarine and a touch of Cadmium Red Hue. Use hair colors for the buttons. Let it dry.

For the shirt, make two blue mixes with French Ultramarine, Cadmium Red Hue and Titanium White. Paint the medium blue thinly, scrubbing with a no. 4 filbert so the grain shows. Paint the dark blue into the shadows with a no. 3 miniature. Use solvent on a clean miniature to lift the paint off the areas where the denim is faded. Blend lightly and let it dry.

6 ADD THE FINISHING TOUCHES

Mix a drop of fine detail drying medium into each color in this step. Mix a small amount of Permanent Alizarin Crimson with Indian Yellow Deep to create a reddish skin tone for glazing. Brush a little on the cheeks, forehead, chin and nose with a no. 4 watercolor round. Add highlights with a mix of Titanium White and Naples Yellow Light on the nose, chin and cheeks.

Paint the eyebrows with a reddish mix of Cadmium Red Hue and French Ultramarine. Use a no. 3 miniature. Use delicate strokes, thinning with solvent. Observe carefully to avoid a plucked look. Mix Mars Black and Permanent Alizarin Crimson for the eyelashes. Brush them on the same way.

Darken the pupils with Permanent Alizarin Crimson and Mars Black. This is the darkest value in the painting.

Restate the lips with a mix of Permanent Alizarin Crimson and Titanium White. Strive for a natural lip color, not too dark. If the face needs more shading, use a dark skin color made from Cadmium Red Hue, French Ultramarine and Titanium White.

Restate the hat trim with a blue and red mixture. Use some of these colors on the darkest areas of the shirt. Brush a little Titanium White over the background with a no. 4 filbert to soften it for a smokier look.

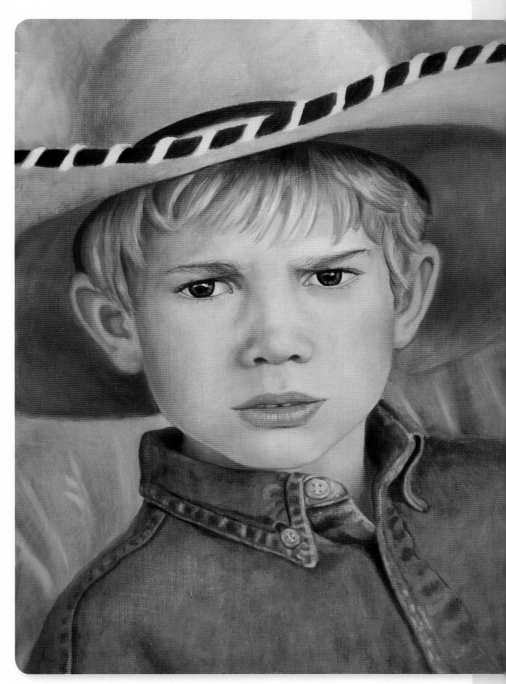

Caden · oil on canvas · 12" × 9" (30cm × 23cm)

CONCLUSION

I hope you have learned some techniques that will enhance your personal style. Oil portraiture has a delightful visual and tactile quality, and there are many exciting moments when painting with oils. Above all, painting should be fun, the process itself rewarding and relaxing. If you are struggling too much, take a break. The painting will wait. All paintings go through ugly duckling stages, so don't get discouraged and don't be afraid to make mistakes. It's only paint and canvas. You can learn a lot from a failed painting. Remember, painting is a lifelong learning process. Good luck and happy painting!

INDEX

THE BEST IN FINE ART INSTRUCTION AND INSPIRATION IS FROM NORTH LIGHT BOOKS!

Painting Children: Secrets to Capturing Childhood Moments
by Bev Lee
ISBN-13: 978-1-60061-038-7, ISBN-10: 1-60061-038-2, Hardcover, 128 pages, #Z1489

Painting portraits of children is a strong artistic tradition, and author Bev Lee will show you how to capture the charm and warmth of children in a fresh and lively manner. She has assembled all the information needed for a successful portrait: posing, composition, skin tones, hair color, texture, clothing, backgrounds, settings and more. All topics will be addressed in the context of how they relate to painting children, allowing you to fully capture their radiance and charm.

Expressive Portraits: Creative Methods
by Jean Pederson
ISBN-13: 978-1-58180-953-4, ISBN-10: 1-58180-953-0, Hardcover, 128 pages, #Z0663

Jean Pedersen teaches how to capture the beauty of the human face and figure. By combining watercolor with other water-friendly mediums, Jean produces rich darks contrasted by extreme lights to create texture-filled paintings that convey the mood and emotion of the subject. The book contains a special chapter on skin tones and how to create the right one for different ethnicities as well as a section on composition and design so that you can direct the viewer's eyes. 28 fully illustrated mini- and full demonstrations show you how to paint a variety of people, sexes, races and ages.

Painting Oil Portraits in Warm Light with Chris Saper
DVD, ISBN-13: 978-1-4403-0523-8, ISBN-10: 1-4403-0523-4, 102 minutes

In this workshop, Chris Saper works with a full palette, giving you lessons in mixing colors for the skin and shadows in warm light.

These books and other fine North Light titles are available at your local fine art retailer or bookstore or from online suppliers. Also visit our website at www.artistsnetwork.com.

Visit www.artistsnetwork.com and get Jen's North Light Picks!
Get free step-by-step demonstrations along with reviews of the latest books, videos and downloads from Jennifer Lepore, Online Education Manager.